THE LITTLE BOOK OF

The

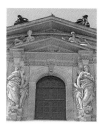

Brigitte Govignon

Flammarion

 Réunion
des Musées
Nationaux

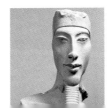

Alphabetical Guide

The alphabetically organized entries have been classified according to the following categories: Architectural Details and History, Artists, Works and Movements. The categories are indicated with a small colored rectangle.

Please note that entry titles have been marked with asterisks throughout this book; use them to cross-reference historical details, artists, works, movements, etc.

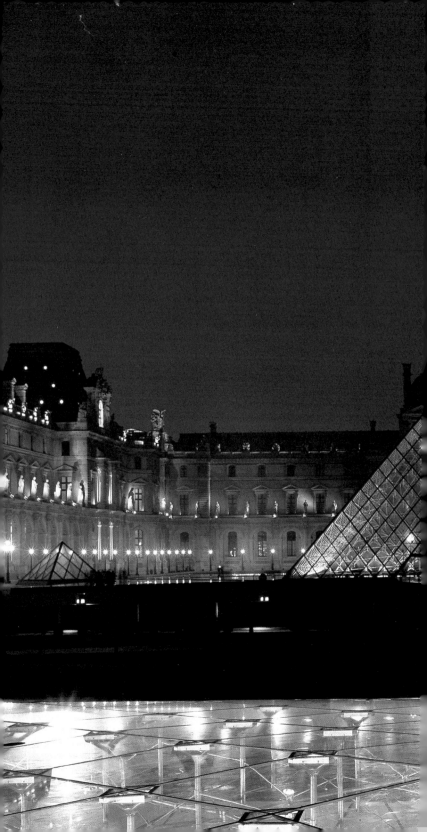

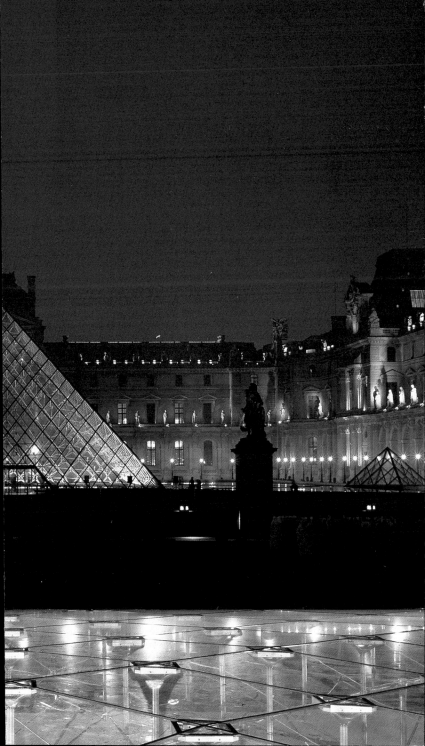

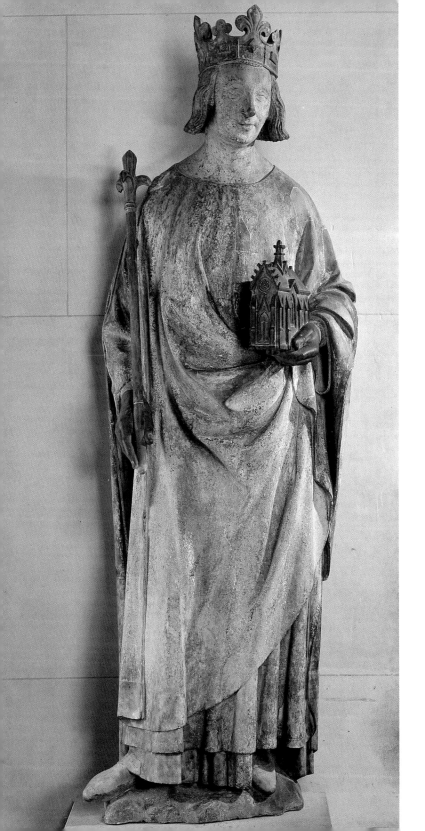

THE STORY OF THE LOUVRE

Evidence indicates that after its transition from more or less open country to a royal hunting ground, the site of the Louvre held a small fortification, then a fort, before becoming a castle and a museum. Today it is not even necessary to use the term "museum" in its name since people all over the world know the Louvre as a place where great art can be seen and consider it one of the greatest museums in the world.

I. FROM FORTRESS TO MUSEUM
Philippe Auguste's Fortress

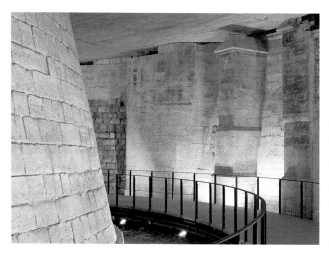

The Louvre Museum: archeological crypt revealing ramparts, donjon and moat of Philippe Auguste's Louvre.

In 1190, when Philippe Auguste decided to make Paris the capital of France, he ordered the construction of city walls, manifesting its political prestige and authority. He added a donjon,* fortifications and two towers, according to the new principles of military architecture. The men and arms necessary for the defense of Paris were garrisoned there. It also contained a dungeon where distinguished prisoners such as Count Ferrand de Flandre, who was defeated at Bouvines, were held. Saint Louis used it as an audience chamber, and Philippe le Bel housed the Royal Treasury there. But Charles V, known as Charles the Wise, decided to transform the uncomfortable fortress into a larger castle, a residence worthy of kings and queens. Sumptuous chambers meeting the royal demand for luxury were constructed. The king's library of 973 manuscripts was placed in the Fauconnerie Tower (site of the Sully Pavilion), and two gardens were created for his

Opposite page:
Charles V, King of France. Limestone. Ile-de-France, fourteenth century.

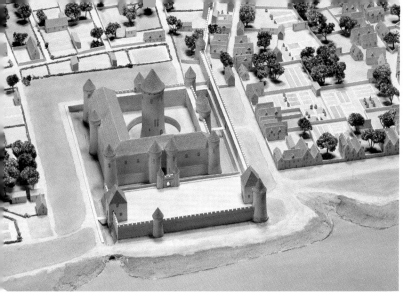

personal enjoyment. A large garden was created to the north and second smaller one near the Seine.

After Charles the Wise's death in 1380, the Louvre lost much of its prestige. The court came to prefer the chateaux of the Loire Valley to Paris. Finally François I sought to gain the good favor of Parisians by residing in "Paris, our fine town and city." He decided to rebuild the still medieval palace according to Renaissance tastes. In 1528, he began to demolish the donjon. In 1540, he received Emperor Charles V with pomp and magnificence, and in 1546, the architect Pierre Lescot was assigned the reconstruction. The Louvre then became one of the royal residences. As a showcase of royal authority, it underwent ceaseless expansion, modification and embellishment. In 1563 Catherine de' Medici had

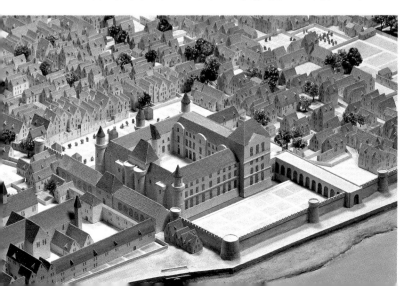

Philibert Delorme design the Tuileries,* Henri IV had the Grande Galerie built where Louis XIII had installed the royal mint and printing house, and Louis XIV was engrossed with the east wing Colonnade.* But the Louvre fell from royal attention for another century when Louis XIV installed his court at Versailles in 1678.

In the absence of the king, royal academies occupied the chambers, and artists and courtiers moved in, taking advantage of the space. The royal art collections remained at the Louvre. But the extremely chaotic environment in which they were housed is difficult to imagine today. Still, starting in 1699, the Painting and Sculpture Academy organized annual exhibitions there. These attracted increasing numbers of visitors each year, winning the close attention of art critics. Denis Diderot's lively and passionate chronicles of the *Salons* of 1758 to 1781 are perhaps the most famous. The transition from palace to museum was well under way.

July 27, 1793: The King's Museum

Abandoned, unfinished, and left to the devices of the scores of people who occupied its increasingly dilapidated structures, when the Louvre became the object of intellectuals' scorn, the king decided to restore a royal residence there as well as to construct halls for the public presentation of his collections. Diderot once again put forward the idea of making the Grande Galerie into a museum in his *Encyclopedia* article entitled "Louvre." This was in 1765, when royal finances were extremely low, which meant that despite Louis XV's interest, the project was abandoned. It was revived under Louis XVI, thanks to the great energy and efficiency of the Count d'Angivillier, who was named Overseer of the King's Buildings in 1774. He purchased prestigious works, catalogued and completed collections, and had paintings restored. He also commissioned statues by great contemporary artists to decorate the future museum. However, the Revolution interrupted the completion of the project.

After the Revolution, the opening of the Muséum Central des Arts* was announced by national decree on July 27, 1793. August 10 saw the opening of the Salon Carré and the Grande Galerie, with installations and work on various exhibition halls to follow. Paintings were then displayed in

The Louvre in 1200 (view from above). R. Munier and S. Polonovski, 1/1000 scale.

The Louvre in 1572 (view from above). R. Munier and S. Polonovski, 1/1000 scale.

the Grande Galerie, and antiquities were exhibited in the Petite Galerie. The most beautiful marble pieces, such as the *Laocoon*, the *Belvedere Apollo* and the *Medici Venus,* which came from the papal Belvedere and Vatican collections, were brought in with great fanfare. A space worthy of their grandeur was necessary, and so the museum of antiquities was established on the ground floor of the Petite Galerie. It opened on November 9, 1800, in the presence of Napoleon Bonaparte and Josephine Beauharnais.

Vivant Denon was named Director of the Museum, which was designated the Napoleon Museum in 1803. An imposing bust of the laurel-crowned emperor by Lorenzo Bartolini was placed on the tympanum of the museum entryway. It is now located in an exhibition hall devoted to the history of the Louvre. Masterpieces snatched up during the Napoleonic campaigns throughout Europe poured into the museum, and it soon became the largest museum in the world. Charles Percier and Pierre Fontaine undertook works of expansion as the emperor's official architects.

When the Empire fell in 1815, France was obliged to return many pillaged works, and so the size of the museum's collection diminished—for a time. But under the Restoration and the July Monarchy, the Louvre was given a boost with the transfer of sculpture from the Musée des Monuments Français (closed in 1817) and development of

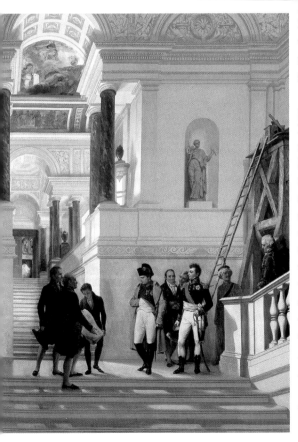

Auguste Couder, *Napoleon Visiting the Louvre Staircase with the Architects Percier and Fontaine,* nineteenth century. Oil on canvas.

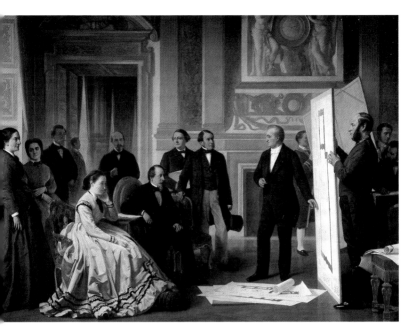

antiquity collections. For instance, after Jean-François Champollion, who first deciphered Egyptian hieroglyphs, was appointed the director of Egyptian and then Assyrian antiquities, the immense Winged Bulls of Khorsabad* entered the Louvre.

Ange Tissier, *Visconti Presenting Napoleon with Plans for the Nouveau Louvre,* 1866. Oil on canvas.

During the Second Republic, Napoleon III sought to complete the ambitious final stage of the constantly delayed architectural linking of the Louvre with the Tuileries. Ludovico Visconti was called upon for the work, but he died suddenly in 1853. Hector Lefuel succeeded him and four years later the emperor inaugurated the Nouveau Louvre. The Nouveau Louvre was all luxury and grandeur; gold and marble are everywhere in the exuberant decor of Napoleon III's Apartments.* But revolt was in the air. In September 1870, the Empire fell and Paris was shaken by the insurrectional government of the Commune (March–May 1871). Gustave Courbet was elected head of the Commission of Arts that was preparing for the reopening of the museum. But when the "Versaillais" entered in the effort to take Paris in their turn, the Communards set fire to the Palais Royal, the Ministry of Finance, the Tuileries Palace and the Beaux-Arts facilities in the Louvre's northern wing. Lefuel soon began restoration work, but the Directorate of the Republic finally decided to do away with that great symbol in the history of kings and emperors of France: what was left of the Tuileries.

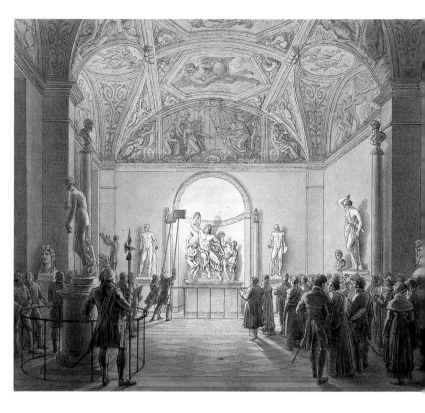

The Grand Louvre

Political turmoil, revolution and war could not stop the continued growth of the Louvre's collections. Progress in museology has led to advances in the presentation of works, evolving art-historical perspectives have influenced the appreciation of works, and increasing public attendance has required perpetual reorganization and new spatial arrangements. Between World War One and World War Two, a global renovation project was undertaken to convert the entire palace into a museum. This was completed with the restoration of the Flore Pavilion in 1977.

Another page in the Louvre's history was turned when François Mitterrand, the then president of the republic, decided to incorporate the headquarters of the Ministry of Economy and Finance into the museum in 1981. This enabled a total redeployment of the collections, the reorganization of the public entry and reception areas, and the exposure of medieval aspects of the Louvre that were unearthed in archeological excavations preceding the renovation work. The American architect Ieoh Ming Pei, already famous for the new wing of the National Gallery in Washington, head-

ed this large project. In 1989 I. M. Pei's glass pyramid* was completed. In the midst of the palace structures, it floods with light Napoleon Hall, the vast public reception area and launching point for a visit to any part of the museum. This symbol of the pharaohs appears here in all its simplicity as a link between the world's oldest civilizations and the newest technologies of the twentieth century.

Benjamin Zix, *The Emperor Napoleon and Empress Marie-Louise Visit the Laocoon by Night,* 1810. Pen and bistre, 10¼ × 15¼ ins (26 × 39 cm).

II. THE EVOLUTION OF THE LOUVRE'S COLLECTIONS

The history of the Louvre is comprised of more than just a series of transitions from royal property to museum. While it first became a museum in 1793, any recounting of the Louvre's history must include the history of its artworks and collections. These collections have been growing since the twelfth century.

The First Royal Collections

Back when the Louvre resembled the famous miniature representation of it by the Limbourg brothers in the *Très Riches Heures du Duc de Berry,* it already had a royal treasury. A century later Charles V kept his collection of beautiful manuscripts there.

François I's excellent eye and intelligent purchases generated the first royal painting collection. In 1516, François I invited Leonardo da Vinci to France, and after his death the king purchased the famous *Mona Lisa.* Later Louis XIV enhanced the royal collections with the aid of his close advisor, Jean-Baptiste Colbert. Louis XIV was so engaged in acquiring paintings (through purchase or commission) that the royal "Painting Registry" (1709–10) numbered 1,478 paintings, of which 930 were French, 369 were Italian and 179 were Northern Renaissance works. In 1671 he purchased the 5,542 drawings of Everard Jabach's collection. Jabach was the first person to be ennobled for such a transaction.

The royal antiquity collections also grew considerably.
Sculpture and marble pieces were mainly acquired from Italy.
The king's close advisors, Cardinal Armand Jean du Plessis de
Richelieu and Cardinal Jules Mazarin were avid and know-
ledgeable art enthusiasts themselves, with their own impressive
collections. The king's antiquities, supplemented by marble
pieces from Mazarin's collection, were moved between Versailles,
the Tuileries, and (after 1692) the new "Salle des Antiques."

The Development and Influence of Archeology

In 1826, Jean-François Champollion purchased a fabulous collection of four thousand Egyptian pieces from the British consul in Cairo, Henry Salt. Champollion was asked to organize an ancient Egyptian department in the Charles X Museum, and very soon 9,000 pieces were installed within halls designed by Pierre Fontaine. Champollion was committed to making the department reflect the breadth and

Guillaume Larrue, *Before the Great Sphinx,* 1935. Oil on canvas, 27 × 34¾ ins (69 × 88 cm).

depth of all aspects of Egyptian civilization, from aesthetic, anthropological and cultural perspectives.

The division of finds between the country of origin and the organizers of archaeological digs was instituted in the mid-nineteenth century, leading to the arrival of the Scribe* and other superb pieces. In 1880, the creation of the French Institute of Archeology in Cairo led to greater organization of excavation sites. After World War Two, finds were less often divided between different countries. However, the museum continued to receive a large number of donations.

At the same time that the Egyptian Museum was being organized, Paul-Émile Botta, the French consul in Mossul, Iraq, discovered the ruins of the Khorsabad Palace, leading to the entry of Assyrian art into the Louvre (1847). Increasingly, places that were distant in time and space came to be represented at the Louvre, which continues to play an important role in many archeological expeditions.

Hubert Robert, *The Louvre's Salle des Saisons,* 1802–03. Oil on canvas, 14½ × 18 ins (37 × 46 cm).

The Growth of the Collections

Purchases: After 1793, painting, sculpture and objects from various royal residences gradually made their way into the Louvre, enriching already established collections. Each subsequent French monarch maintained collections, which usually entered the Louvre. Besides containing magnificent works, they have proven to be extremely rich sources for study.

The acquisition of the famous Borghese collection in 1808 brought the *Fighting Warrior*, also known as the *Borghese Gladiator*,* and four hundred marble pieces. Napoleon III had a great passion for archeology, and in 1862 he bought the Campana Collection.* This brought the Louvre not only the *Sarcophagus of a Married Couple*,* and ceramic works, but also the greatest majolica collection in the world, as well as about a hundred Italian trecento and quattrocento paintings.

The Réunion des Musées Nationaux (RMN) was created in 1895 to direct funds towards the purchase of artworks for collections in national museums. In 1991 it reverted to the Ministry of Culture as a public institution with commercial-industrial status.

Donations and bequests: It would be impossible to list the names of the thousands of donors who generously contributed to the collections. The public is mainly unaware of people such as Louise, Ingeborg and Atherton Curtis (1938, a bequest of 1,500 pieces, including *Raherka and Merseankh**), Charles Sauvageot (1856, a donation of his collection of objects from the Middle Ages and the sixteenth century), Doctor Louis La Caze (1869, a bequest of one of the greatest painting collections in the Louvre), Thomy Thiéry (1902, a bequest of Barbizon School paintings).

A few of the better known contributors include Baron Adolphe de Rothschild, who left the Louvre his magnificent collection of gold and silver religious works from the medieval and renaissance periods; Count Isaac de Camondo left the entirety of his collections, with the stipulation that they

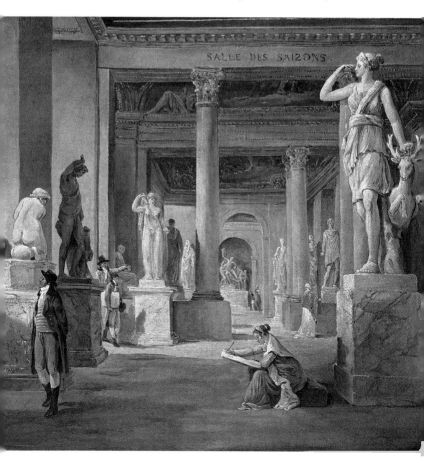

Georges Leroux, *The Grande Galerie of the Louvre Museum*, 1954. Oil on canvas, 3 ft 3 ins × 4 ft 11½ ins (0.89 × 1.51 m).

not be broken up for fifty years; Baron Edmond de Rothschild left his collection of prints, drawings and books just before the Second World War; Mr. and Mrs. David David-Weill and Stavros S. Niarchos left extraordinary French seventeenth and eighteenth-century gold and silver items; Gustave Caillebotte and Étienne Moreau-Nélaton brought the new paintings of their Impressionist friends to the Louvre; and Carlos de Bestegui contributed a magnificent collection of superb portraits.

In some cases an inter-ministerial commission negotiates the remuneration of rights of succession or transfer by means of works of art of equal value. The Société des Amis du Louvre was created in 1897. It enables donors to make anonymous contributions for the purpose of purchasing works.

III. VISITING THE LOUVRE

Several kinds of visits are possible. For people who are pressed for time, documentation is available at the museum to help you locate the masterpieces described in this alphabetical guide. Use these to discover the men and women who have become famous in the Louvre's great halls. There is the smiling *Mona Lisa** and the armless *Venus de Milo*,* the concentrated *Lacemaker** and the professional *Cheat*,* the *Diligent Mother* by Chardin* and the brave young woman known as *Liberty*.* Some of the bold and confident men to be found in these halls include the courageous *Borghese Gladiator*,* the man-god (Amenophis IV*), the man of law (Code of Hammurabi*), the image of conjugal

Giuseppe
Castiglione,
*The Salon
Carré of the
Louvre
Museum*,
1861.
Oil on
canvas,
27 ins × 3 ft
4 ½ ins
(0.69 ×
1.03 m).

fidelity (Albrecht Dürer's* *Self-portrait*), or fearless heroes (*The Oath of the Horatii**).

The seven departments can also be visited in a more systematic fashion. See the splendors of the orient in the Eastern Antiquities and Islamic Arts Collections; the glory of Eternal Egypt in the Ancient Egyptian collections; classical beauty (Ancient Greek, Etruscan and Roman collections); treasures of the Middle Ages and the Renaissance (Decorative Arts); three-dimensional works (Sculpture); painting's infinite perspectives (Painting); and drawings (Prints and

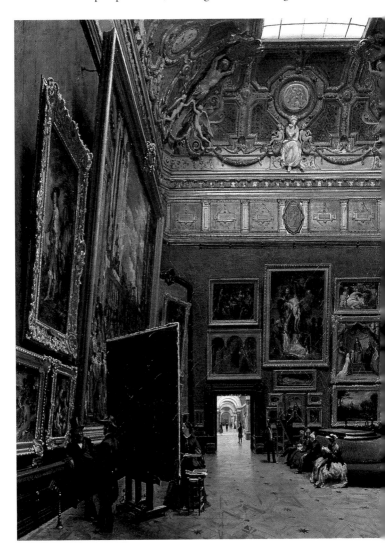

Drawings). Finally, there are the Arts of Africa, Asia, Oceania and the Americas collections, which joined the Louvre in the Spring of 2000.

The Louvre's great history of French architecture—from the thirteenth to the twentieth century—is in evidence everywhere, from the entryway to the halls. The exterior wings can be admired from the banks of the Seine, the rue de Rivoli, the church of Saint-Germain l'Auxerrois and the Tuileries Gardens.

Brigitte GOVIGNON

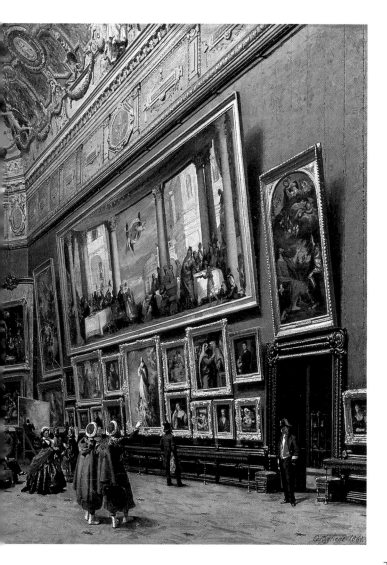

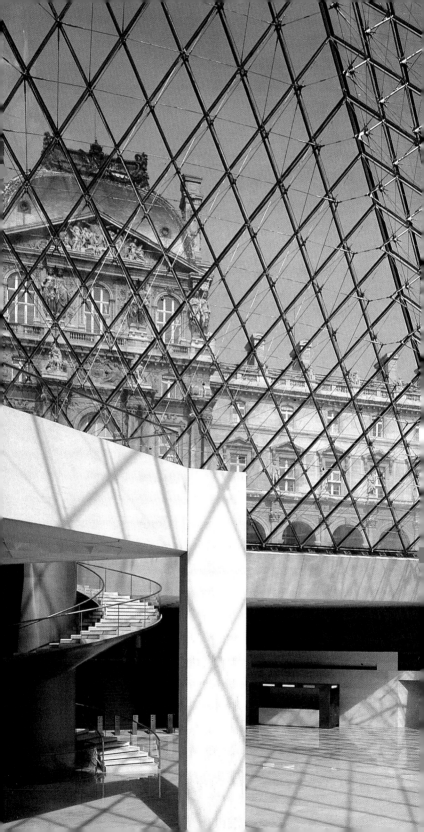

■ Amenophis IV

The New Kingdom (c. 1550–1069 B.C.) is one of the most dazzling periods in Egyptian history. In the Egyptian reunification following the defeat of the Hyksos, the kings undertook grandiose military campaigns, attacking Nubia and the Near East. Riches abounded. Amenophis (or Amenhotep) III (1391–1353 B.C.) initiated a new era of peace. Art flourished and attained a high level of mastery during this period, as evidenced by the fine modeling of the head of Amenophis III from his no longer extant funerary temple in western Thebes. Upon his death, Amenophis (or Amenhotep) IV succeeded to the throne with his wife Nefertiti, who bore him six girls. As a worshipper of Aton, the solar disk and single god, source of all life, the monarch sought to spread his new religion among his subjects. To this end, he constructed several Theban temples consecrated to Aton, and changed his own name to Akhenaton, or "Aton's helper," transferring the kingdom's capital to current-day Tell al-Amarna in Middle Egypt. He there forbade the worship of Amon and proclaimed the Aton cult the official religion.

The *Bust of Amenophis IV* was given to France in 1972 by the Egyptian government in thanks for France's contribution to the preservation of the Nubian temples. A fragment of a Colossus, this head is striking in its representation of the ruler's features. The eyes are soft and slanted, the face narrow, and an enigmatic smile brings the full-lipped mouth to life. A departure from the idealized outlines of earlier eras, this is nevertheless far from presenting a naturalistic portrait; rather it is in keeping with new artistic conventions decreed for the depiction of Akhenaton, who was at once the incarnation of god and the intermediary between the divine and the human.

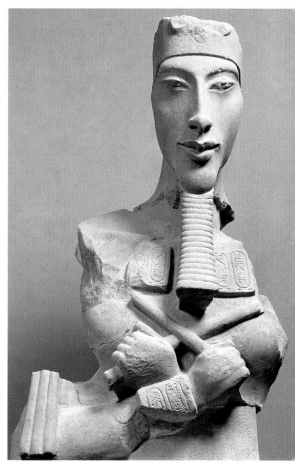

Fragment from a colossus of Amenophis IV, Akhenaton, c.1365–60 B.C. Sandstone with traces of paint, 4 ft 6 ins (1.37 m).

View of the Louvre from within the pyramid.

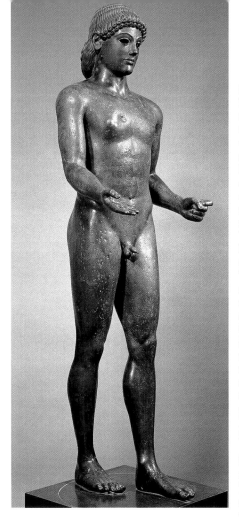

Apollo, known as *Apollo Piombino*, second half of the fifth century B.C., bronze, 3 ft 9½ ins (1.15 m).

Sea near the village of Piombino, facing Elba. Originally the right hand held a bow, and the left hand held a libation vessel. The young god seems to advance with a light step. His left foot bears a dedication to Athena in silver letters. Orderly curls frame the fine facial features, emphasize the strong neck, and model the shoulders. The body's long muscles and harmonious proportions lend a sense of beauty and balance.

The date of this work remains a mystery. Is it a work from the transitional period between the archaic and the classical? Is it from the Hellenistic period? Is it a copy made in the first century B.C. or even the first century A.D.? The 1977 discovery at Pompeii of a comparable statue suggests that this may be an imitation from southern Italy which takes its inspiration from an archaic and classic past.

■ Apollo (Apollo Piombino)

The son of Zeus and Leto, Apollo is the twin brother of Artemis. The god of music and poetry, leader of the Muses, he is nevertheless a cruel and skillful warrior. Symbolizing the Greek ideal of beauty, Apollo may well have been the model for numerous statues from antiquity, including the *Kouros* (575 B.C.) found on the site of the Temple of Apollo in Actium, Greece, as well as the *Apollo Sauroctone* known as the "lizard killer," a Roman copy of Praxiteles' original (c. 350 B.C.).

This handsome bronze Apollo was discovered in the Tyrrhenian

■ Archers of Darius the Great, King of Persia

Herodotus called the Persian archers of Darius I's elite guard the Immortals. This representation of them, with bows and quivers on their shoulders and spears at their feet, comes from the palace walls at Suza. The guards are all in the same position. Whether heading left or right, they are dressed in embroidered formal robes, with their twisted hair tied and their well-trimmed beards looped in position. They bear witness to the virtuosity of Persian wall-enamel arts, which first appeared in the second millennium B.C. and survived through the great Islamic empires.

Darius united the various peoples of Iran in a vast empire that extended from Egypt to India. He established his capital in the

3,000 year-old metropolis of Susa, and founded a new city, Persepolis, in his native province. He brought in architects, masons, sculptors, goldsmiths and silversmiths from all over his empire to build his palace, and he erected an "apadana," a vast column-enclosed court chamber, at both Susa and Persopolis. The Susa apadana was augmented with a palace whose typically Mesopotamian characteristics included traditional raw brick walls covered with a layer of colored glazed bricks representing the archers, servants carrying tributes and the imposing animals that symbolized the divine protection accorded by the god Ahura Mazda.

The Archers of Darius, c. 500 B.C. Terracotta with polychrome glaze. Archer height, 5 ft 3 ins (1.60 m).

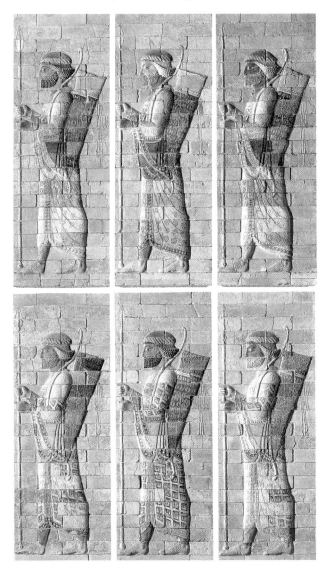

■ ARCHITECTS OF THE LOUVRE

I t took eight centuries to build the Louvre: Eight hundred years of transformation, demolition, extension, and reconstruction. Builders and architects took what was initially a fortress (*lower* in Saxon, hence *Louvre*) and made it into a great museum whose design and décor are masterpieces in their own right. The first among them, Raymond du Temple, architect to Charles V, converted the Louvre into a royal residence. He pierced windows in the stone and created new living spaces and two main buildings accessed by a monumental spiral staircase.

In 1546, upon the request of François I, Pierre Lescot, with the collaboration of the sculptor Jean Goujon, undertook the building of a "large residential edifice" in place of the western wing. This produced the west and south facades of the Cour Carrée.*

In 1563 the Queen Mother Catherine de' Medici, who found the castle quarters a bit close, commissioned Philibert Delorme to design an immense palace to be erected in the neighboring Tuileries.* Only a portion of this project was realized.

Jacques II Androuet du Cerceau and Louis Metezeau designed the Grande Galerie* (1595–1610), which measures 460 meters and is also referred to as the "gallery along the water." It joined the Louvre Castle to the Tuileries Palace.

Jacques Lemercier built the Horloge Pavilion, doubled the length of the western wing, and began the fourfold enlargement of the Louvre courtyard.

The Colonnade was constructed from 1668 to 1678, ceremoniously opening the Louvre out to the city. It is the work of Claude Perrault, Louis Le Vau and François d'Orbay.

In 1754, Jacques-Ange Gabriel and Germain Soufflot resumed work that had stopped upon the death of Louis XIV in 1715.

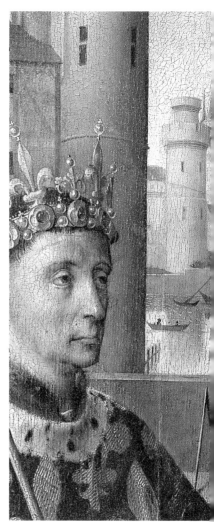

Flemish painter working in Paris, *Parliament of Paris* (detail), c. 1452. Oil on wood, 8 ft 10¼ ins × 7 ft 5 ins (2.70 m × 2.26 m).

Napoleon commissioned Charles Percier and Pierre Fontaine to finish the buildings. They unified the façades of the Cour Carrée. Fontaine introduced plans to connect the two palaces, and construction soon began on a new wing along the rue de Rivoli.

Félix Duban was Fontaine's successor. He restored the facades of The Petite and Grande Galeries.

Napoleon III selected Ludovico Visconti's project to join the Louvre and the Tuileries definitively. Although Visconti died in 1853, work continued according to the original plans under Hector Lefuel. Lefuel reconstructed a portion of the Grande Galerie and the Pavilion de Flore between 1861 and 1865. Following the Tuileries fire of May 23, 1871, during the fall of the Commune, Lefuel repaired the Richelieu Wing, restored the Pavilion de Flore, and erected the Pavilion de Marsan.

Ieoh Ming Pei was chosen in 1983 as the architect for what we now call the Grand Louvre. The glass pyramid* which marks the museum's new main entry was inaugurated in 1989, as part of the commemorations of the bicentennial of the French Revolution.

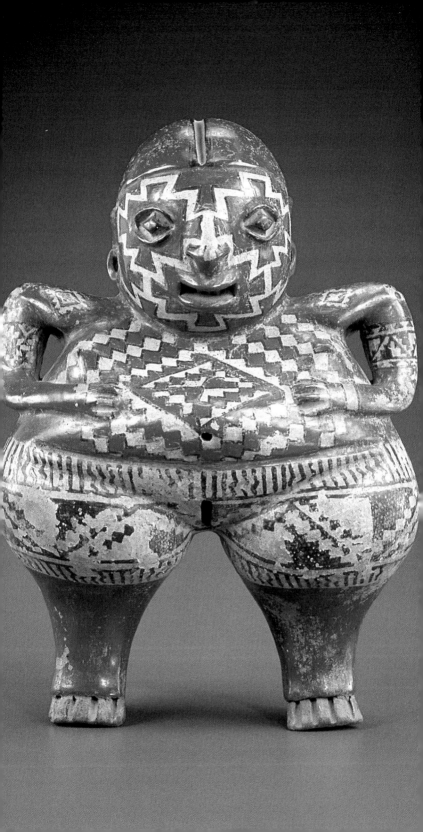

■ Arts of Africa, Asia, Oceania and the Americas

"Many want to see the art of Africa in the Louvre, and one day they will," said André Malraux in 1976. On the initiative of French President Jacques Chirac, so-called "primitive" art is now on view at the Louvre, along with the *Winged Victory of Samothrace* and *Mona Lisa*. The renovated Sessions Pavilion now houses more than a hundred masterpieces, grouped by geographical origin, in an itinerary running from west to east, from Africa through Asia to Oceania, and from northern-most America (the Antarctic) to South America.

The terracotta Chupicuaro Sculpture's ample thighs, rounded belly, small bent arms resting on hips, raised shoulders and head with its prominent nose represent the central role of femininity in the world-order of ancient Mexico. The work serves as a symbol of the earth, seasonal renewal, fertility, and nourishment. The artist emphasized the form's fullness by making it a striking red on which is superimposed a geometric pattern comprised of broken lines, ovals and black and white squares. The designs on her trunk and hips probably evoke the painting of women's bodies for ceremonies. In all, the lively patterns cloak the figure in magical and mysterious power.

Chupicuaro sculpture, 600–100 B.C. Terracotta, 12¼ ins (31 cm).

Baptistry of Saint Louis, Egypt or Syria, c. 1320–30. Brass with gold, silver and black inlay, diameter 20 ins (50.5 cm).

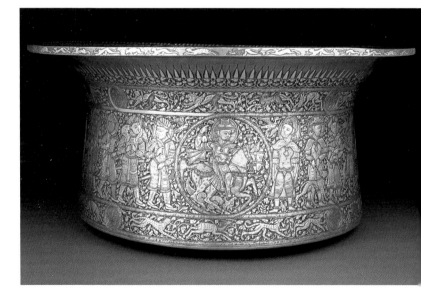

Sculptures were selected from among thousands of works in French and foreign collections. Each one is exemplary of the creativity and talent of anonymous artists. Defying space and time, they offer a real "Journey to Adventure."

■ Baptistry of Saint Louis

Even though the signature of Muhammad ibn al-Zayn appears six times on this masterpiece of Mamluk art, dating it has been the subject of some controversy. Its gradually narrowing form

leading to a flared rim tends to place it during the reign of one of the greatest of Mamluk sovereigns, Muhammad Ibn Qala' un (Al-Nasir Muhammad).

The bowl is composed of solid brass. On the surface there is a series of dignitaries on foot, often with game. Others bear symbolic emblems, such as the lord of the royal wardrobe who is holding a folded cloth. These figures stand out against a magnificent background of vegetation in which small, partially concealed animals can be discerned. The large band is interrupted by medallions depicting the prince on his throne. He is flanked by a man of letters, his secretary, and a man of war, the armorer. On the inside are scenes of warriors; horsemen in coats of mail alternate with hunters. In the nineteenth century, two medallions on the transversal axis were covered over with the arms of France. These were affixed there for the baptism of the imperial prince Napoleon-Eugene. The bowl was given the name "Baptistry of Saint Louis" in the eighteenth century, because of the belief that it had been used for the baptism of Louis XIII and the royal offspring. The fish on the bottom are the most damaged part of the piece.

■ Baroque

Baroque art started in Italy at the end of the sixteenth century. Following the Council of Trent (1545–63), which was decreed by Pope Paul III to reorganize the Catholic Church and reaffirm the Faith, artists were encouraged to glorify the Church Universal and Triumphant. First applied to architecture and sculpture in Rome, the term baroque came to encompass all forms of creative activity: theater, music, painting, the decorative arts, furniture and gardens. It provided Christian art with a burst of energy that lasted through the two centuries preceding the French Revolution in Europe, and its domination and impact spread from Europe throughout the world, including China and Latin America.

Heinrich Wölfflin, in his influential *Principles of Art History* (1915) definitively characterized the baroque style by contrasting it to the classicism* that followed it. According to Wölfflin, classicism is rigorous and elicits the faculties of reason, while baroque is exuberant and works along the lines of emotions, formal excess, and illusion. In seventeenth-century France, the prevailing taste for classicism* gave rise to a special sense of equilibrium as a response to international baroque currents.

Pierre Puget (1620–1694) divided his time between his native Provence and Italy, where the baroque as well as ancient Rome inspired and informed his work. He successfully tempered his Mediterranean spirit to fit within the bounds of French baroque preferences. Two of his marble masterpieces are on display in the Cour Puget*: *Milo of Croton Attacked by a Lion* (1670–82) and *Perseus Freeing Andromeda* (1684). Both statues were designed for the Versailles gardens. The first narrates the hero's moral and physical suffering while the second, with its asymmetrical composition and strong contrasts, is one of the most baroque examples of French sculpture.

Pierre Puget,
*Milo of Croton
Attacked by
a Lion,*
1670–82.
Marble,
8 ft 10¼ ins
(2.70 m).

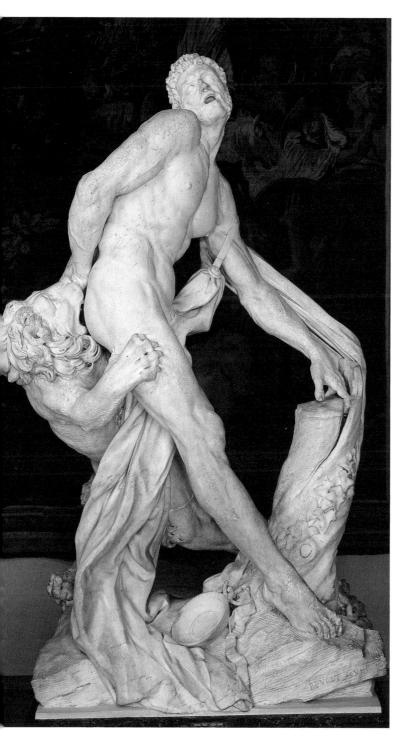

Pierre PUGET (1620-1694)

■ BATTLE OF SAN ROMANO

I n 1432, the Florentines defeated the Sienese. To commemorate the victory, Cosimo de' Medici commissioned Paolo Uccello (1397–1475) to execute three large paintings retelling key moments of the battle for his palace in Florence.

Micheletto da Cotignola which led to the final victory. The viewer is drawn into the fray by the activity of the horses. On the far right a brown horse stands alert, while alongside and further in a white horse begins to advance towards the fray.

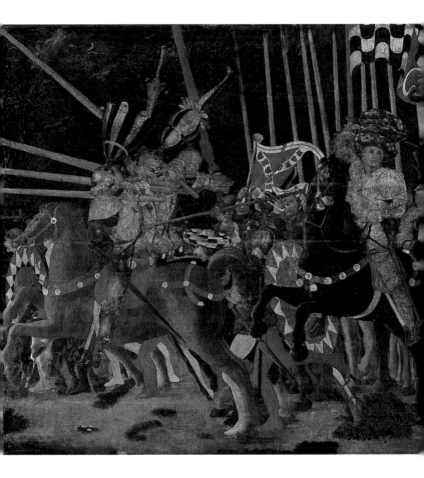

The panels were completed around 1450, and are on display today at the National Gallery of London (*Niccolò da Tolentino Commanding the Florentines*), the Uffizi in Florence (*Bernardino delle Ciarda Thrown from his Horse*), and the Louvre. The Louvre panel depicts the counterattack of

Micheletto's black horse breaks into a gallop, and the brown horse at the left of the panel exits the scene at full speed. The rhythm created by the lances also punctuates the battle's progression, whose successive movements are enlivened by the soldiers' shining armor. The background

profusion of multicolored legs evokes a sense of depth and demonstrates Uccello's resolution of the problem of perspective, the topic of his research and a personal passion. "What a sweet thing perspective is," he is quoted as saying.

Medici commissioned the panels of the Florentine victory. In Urbino, Uccello painted the predella of an unfinished altarpiece, *The Miracle of the Host*, a series of lively and lyrical scenes that attest to his talent for narration and decorative handling.

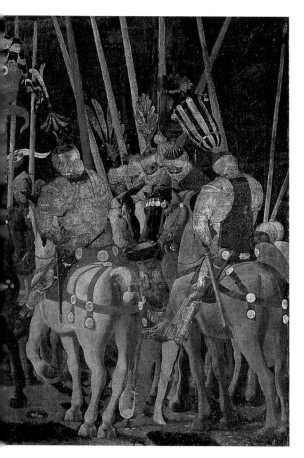

Paolo Uccello,
Battle of San Romano,
Counterattack
of Micheletto da
Cotignola, c. 1456.
Oil on wood,
5 ft 11½ × 10 ft 4¾ ins
(1.82 × 3.17 m).

Uccello was born in Florence, lived in Venice from 1425 to 1430, before returning to Florence, where his career developed. Around 1436 he painted the Duomo fresco *Monument to John Hawkwood,* a monumental and geometric equestrian portrait. It was probably at this time that Cosimo de'

A unique and complex artist of the Florentine Renaissance, Uccello imposed his scientific learning in the rendering of perspective without neglecting the pomp and circumstance of Gothic tradition.

Pieter Brueghel
the Elder,
Beggars, 1568.
Oil on wood,
7 × 8¼ ins
(18 × 21 cm).

▪ **Beggars**

There are five of them in this little painting: five crippled beggars ridiculed by their own grotesque hats. Behind and to the right, a figure exits the scene, carrying what seems to be an abalone shell. The beggars are all facing in a different direction on their wooden crutches. The meaning of the work, one of Brueghel the Elder's (c. 1525–1569) last, remains a mystery. The painter may have intended to depict the five social classes: the king with his cardboard crown, the soldier with a paper hat, the bourgeois with his beret, the peasant with his cap, the bishop with his paper miter. Even in this small work, Brueghel proves himself the consummate painter of Flemish peasant life, whose fairs, celebrations, and traditions were his constant subject. He was also a master of landscapes of the Flemish plain and lakes, for example in "Months," commissioned by a wealthy Antwerp financier. In the five canvases remaining from this series, peasant life unfolds in keeping with the seasons, conveying a lively and vivid world.

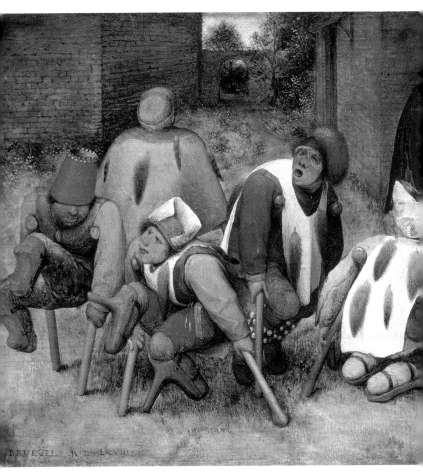

■ Borghese Gladiator

This figure was historically but inaccurately said to be a gladiator. In fact, this statue depicts a warrior battling an equestrian adversary. The soldier attempts to protect himself with a shield attached to his left arm, before striking his enemy with a sword in his right hand. The signature of the artist, Agasias of Ephesus, is carved in the tree trunk. The sculpture was acquired by Napoleon from Prince Borghese in 1807 with the entirety of the Borghese family collection. This much-appreciated work has often been copied over the centuries. The figure's elegant, streamlined proportions bear witness to the sculptor's mastery. The slightest muscular detail is faithfully rendered in the marble. The rotational movement of the body, from the left foot to the crown of the head, creates a powerful diagonal support for the entire mass. Dating from the Hellenistic period, this work demonstrates the sustained influence of classical Greek sculpture throughout this era.

Fighting Warrior known as the *Borghese Gladiator*, c. 100 B.C. Marble, 6 ft 6¼ ins (1.99 m).

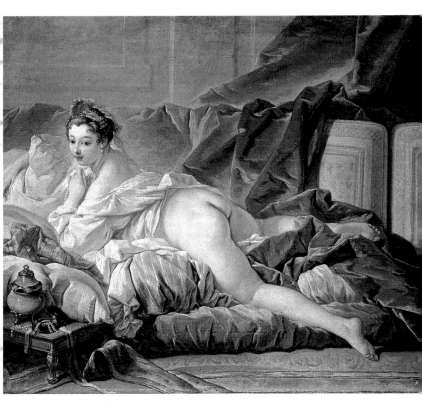

Boucher (François)

For more than thirty years, François Boucher (1703–1770) dominated French painting with his great talent and productivity. He garnered every honor in the course of his brilliant career. His output includes religious and secular subjects, landscapes, book illustrations, drawing and decorative works. The abundance of activity at times made for facile results, but his artistry stands as a lasting tribute to femininity. Goddesses, mothers, socialites, sybarites and innocents alike are celebrated by the painter for their beauty and charm.

Trained in the decorative tradition at the Lemoyne workshop, Boucher first earned his living as an illustrator and engraver in Jean-François Cars' workshop. In 1724 he was awarded First Prize by the Academy, which sent him to Rome. He remained there until 1731, studying

François Boucher, *Odalisque*, 1755. Oil on canvas, 21 × 25½ ins (53.5 × 64.5 cm).

Pietro da Cortona's baroque compositions and Correggio's paintings. Elected to the Academy for his *Renaud and Armide,* he was named professor, then director, and in 1765, first painter to the king. His productivity was intense and his success immediate. He found the time to head the Beauvais and the Gobelins Royal Tapestry Works, to design theater and opera sets, and to fulfil the king's commissions as well as those of Madame de Pompadour, whose staunch support procured him lodgings at the Louvre in 1752. The *Psyche* tapestries (1739), along with the two acclaimed *Loves of the Gods* series established Boucher as the most prodigious and inventive decorator of the century of Louis XV. The artist's virtuosity makes itself felt in all of his endeavors, from sweeping mythological scenes to portraits *(La Marquise de Pompadour).*

■ CAMPANA COLLECTION

This collection and the Gallery are named for the Marquis Giampietro Di Cavelli de Campana (1807–1870), a passionate Italian collector of antiquities and paintings. He acquired Greek, Etruscan, and Roman works, early Italian paintings and majolica pieces, and ordered numerous archeological digs on the site of the Etruscan necropolis of Cerveteri, to the north of Rome. Bankrupt from the purchase of over 11,000 works of art, Campana served two years in prison for attempted embezzlement, and his collection was confiscated. In 1861 Napoleon III, an archeology enthusiast, bought the majority of the collection.

In Paris the following year, the four million objects, including 300 marble sculptures, were the talk of the town. The excellence of the Louvre's holdings in Greek ceramics is due to this collection. A portion of the works were sent to museums in other French cities.

The collection was initially displayed at the Palais de l'Industrie, then called the Napoleon III Museum, and from 1863 to 1869 it was transferred to the Gallery of Antique Bronzes (Sully Pavilion, first floor) which had been newly fitted out by Lefuel.*

Michel-Martin Drölling, *Louis XII Proclaimed "Father of the People" in Tours,* 1828–33. Painted ceiling of salon 43, second room.

The department of antique ceramics was inaugurated on August 15, 1863, taking the name of the Campana Gallery. In these nine adjoining rooms, immense oak and mahogany display cases were built to present all the works of this vast collection. The painted ceiling dates from 1833. It depicts the history of France and the arts, because the space was formerly used for industrial design exhibitions and the Salon of Living Artists.

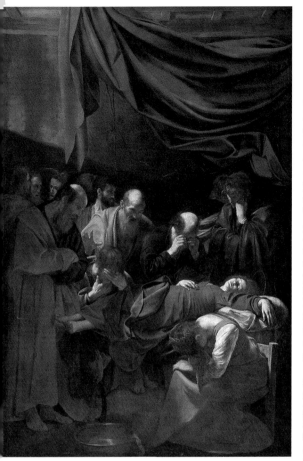

From 1600 onward, Caravaggio devoted himself to religious subject matter. He developed a monumental style which relies heavily on strong contrasts between light and shadow, as exemplified by the *Death of the Virgin*. For models of virgins and saints, he chose ordinary and indigent people he met on the streets and in taverns. His lifestyle provoked scandal, and he ran into difficulties with the law. When he was accused of murder in 1606, Caravaggio fled first to Naples, then to Malta and Sicily. His work became more dark and brooding, and the chosen themes less violent *(The Nativity, Adoration of the Shepherds)*. Hearing that the pope was planning to grant him grace, Caravaggio returned to Naples, where he was found dead on the beach of Porto Ecole at the age of thirty-seven.

In its opposition to both academic classicism and baroque illusionism, Caravaggio's work created a revolution in painting. By imposing a direct, brutal confrontation with reality, his canvases dominate the viewer's gaze and demand an emotional response.

Caravaggio, *Death of the Virgin,* c. 1605–06. Oil on canvas, 12 ft 1¼ × 8 ft ½ ins (3.69 × 2.45 m).

Caravaggio (Michelangelo Merisi)

The innovations of Caravaggio (1571-1610) profoundly influenced the greatest European painters of the seventeen century, and the future of painting itself. Trained in Milan, Caravaggio went to Rome at the age of twenty. There, he led a carefree existence, painting for his living and attracting the attention of several prelates. In 1598 he received a major commission to decorate the Contarelli Chapel in the Church of San Luigi. An unmitigated and dramatic realism charges Caravaggio's three scenes of the life of Saint Matthew with new emotional force, revealing the depth of his genius in a complete break with the mannerist conventions of his time.

Chardin (Jean-Baptiste Siméon)

Chardin (1699–1779) spent the whole of his painting career in Paris, between his birthplace on the rue de Seine and the Louvre, where he lived the last

twenty years of his life. He studied in several workshops, and at the age of twenty-eight presented two paintings to the Royal Academy of Painting: *The Ray-fish* and *The Buffet. The Ray-fish* inspired immediate admiration and earned Chardin a place in the Academy. He was soon recognized as the greatest still-life artist of his century. Slowly and painstakingly, he composed small canvases meticulously depicting the modest world of kitchen utensils and everyday objects. Around 1730, he began to paint genre scenes illustrating the intimate details of daily domestic life in the seventeenth-century Dutch tradition.

These compositions were highly esteemed in Paris and other European courts. The delicacy of Chardin's small-scale masterpieces appealed to Louis XV, who in 1751 commissioned *The Bird-song Organ,* which depicts a young girl teaching her canary to sing. This is one of the artist's last narrative scenes. Chardin, the painter of "silent life," then returned to his first love, the still life. At the age of sixty-one he produced several pastel self-portraits which display powers of psychological perspicacity. At the time of his death he had already been forgotten by a public who had turned to the easier art of Greuze and Vernet.

Jean-Baptiste Siméon Chardin, *Diligent Mother*, 1740. Oil on canvas, 19¼ × 15 ins (49 × 38 cm).

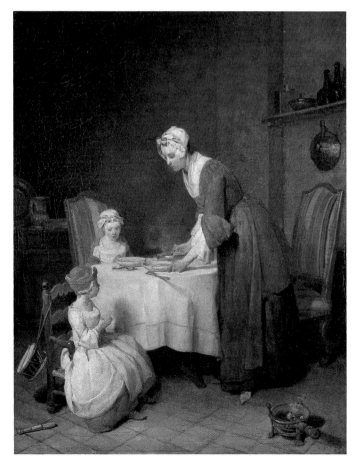

■ CHEAT

Born in Lorraine, France, to a family of bakers, Georges de La Tour (1593–1652) probably studied the work of Caravaggio—whose influence seems indisputable—somewhere outside of Italy. He was married at the age of twenty-three in Lunéville, where he settled in the following year. His talent gained quick recognition and a flood of commissions. La Tour painted and sold a great many works, ceaselessly reworking key themes in subsequent paintings to the point of perfection. In addition to the two *Cheats* and the two *Magdalenes,* there are four different versions of certain of his candlelit scenes. His way of working is evidence of the artist's success among a widening clientele. Only forty works from his vast output

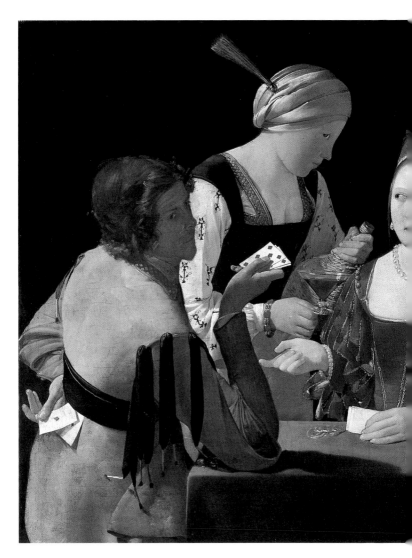

were to survive the disasters which ravaged Lorraine in 1638. Among the early works, *Cheat with the Ace of Diamonds*, with its shimmering, clear colors, stands out as a masterpiece. In the center of the composition, a lofty courtesan impatiently waits for a glass of wine from her servant. The idea is clearly to intoxicate the wealthy young man at the right, who notices neither the cheat pulling an ace of diamonds from behind his belt, nor the women's conspiring gaze. In his stiff and sumptuous brocade shirt, with his round child-like cheeks, the youth is the victim of a charade played out at his expense. The shade falling across the cheat's face reveals the sleight of hand destined to change the young man's future while emphasizing the courtesan's white complexion and her servant's delicate profile topped with a gold turban. The other, probably earlier version, *Cheat with the Ace of Clubs* (Kimball Art Museum, Fort Worth, Texas) differs in a few details.

The night scenes which constitute an important share of La Tour's production contributed greatly to his success and renown. Of uncertain date, the religious scenes and penitent *Magdalenes* are lit by a single candle which outlines the volumes and simplifies the forms. This lighting allows the painter to focus on the essential, bringing the object of contemplation and religious fervor forth from the shadows.

Georges de La Tour,
*Cheat with the Ace of
Diamonds*, c. 1630.
Oil on canvas,
3 ft 5¼ ins × 4 ft 9½ ins
(1.06 × 1.46 m).

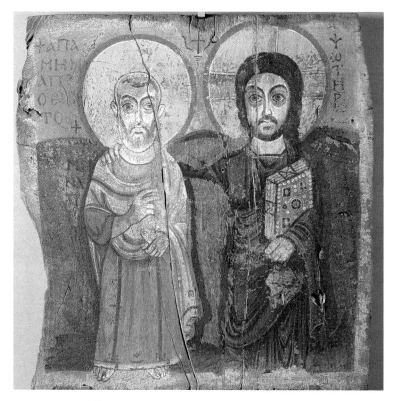

Christ and the Abbot Mena, seventh century. Painted wood, 22½ × 22½ ins (57 × 57 cm).

■ Christ and the Abbot Mena

This wood panel was found in Egypt among the ruins of a Coptic monastery in Bawit. The magnificent icon depicts Christ protecting the Abbot Mena, the monastery's superior. Christ encircles the abbot's shoulders with one arm. In the other arm, he holds the Book of the Gospels, whose richly bejeweled binding contrasts with the sobriety of his attire. In his left hand, the abbot holds a parchment roll, perhaps listing the monastery rules. The figures stand in a green landscape. Both are haloed in gold, but Christ's nimbus is larger.

The Monastery of Apa Apollo at Bawit was founded at the end of the fourth century in Egypt, where monastic life had originated a century earlier. It bears witness to the profusion of monastic communities throughout the Nile Valley. Christian or "Coptic" art in Egypt was practiced between the fourth and twelfth centuries. In the Louvre's Bawit Room, a reconstruction of the southern church presents carved elements found in the excavation, column capitals embellished with plant motifs and crosses, sculptures, and geometrical frescoes from a large building of

the same monastery. The originality of Coptic creation is evident in its brightly-colored linen and wool textiles, of which the museum possesses an exceptional collection. These tapestries bear motifs often borrowed from the Roman tradition (*Sabine's Shawl*).

Classicism

A quest for rigor, majestic harmony and straight lines might describe the ideal of classicism, in contrast with baroque* exuberance, mannerist extremities, and Romantic* emotionalism. The classical movement was centered mainly in seventeenth-century France and Western Europe. It took its inspiration, references, and models from the art of antiquity and the great sixteenth-century masters. Poussin* (1594–1665), who lived out his career primarily in Rome, is one of the great

figures of French classical painting. Relying on the study of antiquity, he selected noble subjects capable of conveying moral and philosophical concepts. His more energetic youthful style gives way to mature compositions which are ponderous, solemn, rigorously symmetrical, and bathed in rarefied light.

The portraits of Philippe de Champaigne (1602-1674) are outstanding for their sobriety, their insistence on simplicity, and their spirituality. Another example of classicism is to be seen in the elegant and calm harmony of Eustache Le Sueur's (1616–1655) canvases.

French classicism is closely associated with the reign of Louis XIV, whose encouragement of the artistic expression of his absolute monarchy influenced the movement. Artists were trained by the Royal

Philippe de Champaigne, *The Ex-voto of 1662.* Oil on canvas, 5 ft 5 ins × 7 ft 6 ins (1.65 × 2.29 m).

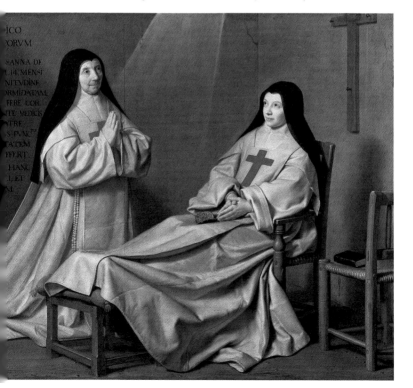

Academy of Painting and Sculpture (founded in 1648) and by the Royal Academy of Architecture (1670). The most promising among them, upon obtaining the Grand Prix, were sent to Rome, the Eternal City. Upon their return to Paris, they received official commissions and teaching positions, and their work bears witness to the royal authority.

just sentences that Hammurabi, a wise king, bestowed so that his people may exercise firm discipline and proper conduct."

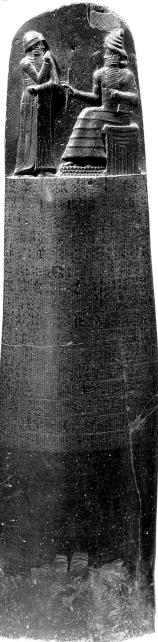

Legal Code of Hammurabi, eighteenth century B.C. Basalt stele, 7 ft 4½ins (2.25 m).

■ Code of Hammurabi

Hammurabi (1792–1750 B.C.) was the sixth king of Babylon. He is represented at the summit of the stele in the presence of Shamash, god of justice. The standing, crowned king, his right hand bent in prayer, attends upon the enthroned god whose headpiece sports four pairs of horns. Flames bursting from the god's shoulders are a reminder of his status as sun god as well. He holds before the king a rod and measuring cord, instruments of justice. Below this majestic encounter between king and god, the legal code is written out in elegant cuneiform. Two hundred and eighty-two case laws comprised of 3500 lines are arranged in vertical rows. The same text was engraved on steles placed in all the cities of the Babylonian Empire. The epilogue makes Hammurabi's intentions and their effects clear. It reads: "Such are the

Pierre-Antoine Demachy, *View of the Louvre Colonnade,* 1772. Oil on canvas.

■ COLONNADE

The Louvre's eastern façade, facing the Church of Saint-Germain-l'Auxerrois, was destined to become a monumental frontispiece. Construction was begun by Louis Le Vau. Upon his nomination to the post of Superintendent of Buildings in 1664, Colbert ordered the work to be stopped and commissioned new plans from several architects. Still unsatisfied, he turned to Italy and solicited projects from Pietro da Cortone, Carlo Rainaldi, Candiani, and Giovanni Lorenzo Bernini. Bernini presented a grandiose scheme little suited to the French climate. Brought to Paris, he was received with the highest honors on June 2, 1665. Once in France, he designed a new project comprised of a colossal façade with a central pavilion which gained King Louis XIV's approval. The first stone was solemnly laid on October 17, three days after the departure of Bernini, who left behind his assistant Mathias de Rossi. But the plans were soon abandoned. The sole traces of Bernini's stay in France are a bust of the monarch in Versailles and an equestrian statue, a copy of which is located in the Cour Napoléon.

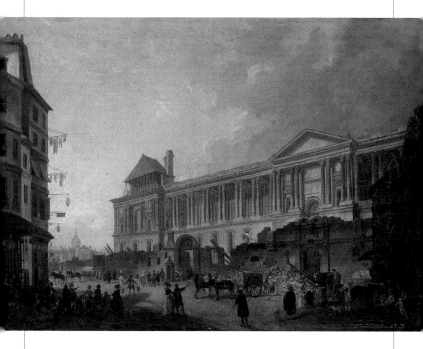

In 1668, work was resumed under the authority of Claude Perrault, Louis Le Vau, and François d'Orbay. Meanwhile the king decided to make his main residence at Versailles instead of Paris, losing interest in the Louvre. The Colonnade was finished ten years later. Its monumental peristyle is adorned with double Corinthian columns set forward from the wall. An austere and harmonious emblem of French classicism, it is one of the finest examples of the architecture of its time.

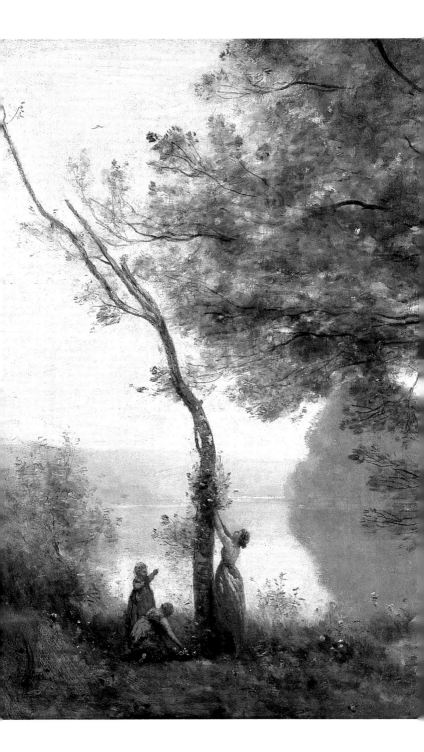

Camille Corot, *Souvenir of Mortefontaine*, 1864. Oil on canvas, 25¼ × 35 ins (65 × 89 cm).

Corot (Jean-Baptiste Camille)

Delacroix declared Corot (1796–1875) "a rare genius and the father of modern landscape." This calm and solitary painter did indeed reinvent landscape painting in France.

After studying with the landscape painters Achille-Etna Michallon and Jean-Victor Bertin, Corot set out for Italy in 1825, where he remained for three years. While there he made numerous landscape studies from nature, which he would use in the large, calm, and balanced compositions he showed at the Salons. Corot lived an itinerant life, seeking out varied landscapes throughout France, and travelling to Switzerland, Holland, and London. He spent the winters in his studio, working on shadings and attempting to depict the elusive beauty of morning light. For thirty years, he lead a solitary life, in near-complete anonymity, with no signs of public appreciation.

He made two additional trips to Italy. From 1835, he began to show landscapes elaborated in his studio and enlivened with Biblical or mythological scenes at the yearly Salons. His palette took on new silvery gray tones as he became more and more attracted to Northern light. The public began to respond enthusiastically to his melancholy scenes where miniscule silhouettes of nymphs and girls dance through forests, such as in *Souvenir of Mortefontaine*. Corot also excelled in portrait, nude, and genre painting. Large female figures feature in every period of his work; one of the finest is his *Woman with a Pearl* of 1869.

Horloge Pavilion, Jacques Lemercier, 1624–40.

■ COUR CARRÉE

When François I decided to transform the Gothic Louvre into a Renaissance palace in 1527, the donjon which obstructed light from the main courtyard was removed. The Renaissance façade, begun in 1546 and today the Louvre's oldest, was built covering the preexisting walls during the reign of Henri II. Designated by the name of its architect Pierre Lescot (1515–1578), this southwest wing stands as a manifesto of French Renaissance architecture. It is embellished with figures in high relief by the sculptor Jean Goujon (active 1540–63) which constitute a hymn to the monarch. The wing joins the King's Pavilion to the south.

The square (*carrée*) courtyard was envisioned by Henri IV and constructed through the reigns of Louis XIII and Louis XIV. In 1639, Jacques Lemercier doubled the length of the west wing and erected the Horloge (clock) Pavilion, a pendant to the King's Pavilion. He maintained the bases of Lescot's design. Le Vau, architect to Louis XIV, finished the courtyard's northern and southern façades. To the east stands the Colonnade* façade.

The Cour Carrée, which housed a kind of shanty-town in its center until 1801, and whose roofing on the northern wings is still unfinished today, was a highly picturesque site when Napoleon ordered the final unification of the buildings by the architects Charles Percier and Pierre Fontaine.

In 1985, following excavations which permitted the uncovering of elements of the medieval Louvre and the donjon, the courtyard was paved and a circular fountain was added to its center.

COUR CARRÉE

49

■ COUR MARLY AND COUR PUGET

The two courtyards, located between the rue de Rivoli and the Cour Napoléon, were designed by Ieoh Ming Pei and Michel Macary to display the collection of large sculptural works in daylight. Glass panels which soften the natural light with visor strips were designed by Peter Rice to illuminate these two magnificent sculpture galleries.

Begun in 1852 by the architect Ludovico Visconti as part of Napoleon III's Nouveau Louvre, construction of the courtyards was completed by Hector Lefuel.* They were designated for use by the Ministry of State and the Imperial Barracks in 1857.

The Cour Marly houses sculptures from the royal residence of Marly, a place of rest and privacy for the Sun King Louis XIV and his immediate entourage. The two equestrian groups placed at either end of the terrace were commissioned from Antoine Coysevox for the castle's horse-watering pond. They celebrate the king's glory in the capacity of warrior *(Fame)* as well as peacemaker *(Mercury Astride Pegasus)*. In 1719, Louis XV had these statues moved to the Tuileries and replaced them with two new groups commissioned in 1739 from Guillaume Coustou. Remarkable for their evocation of vigorous energy, these sculptures gained renown under the name of the *Marly Horses*. They were installed in the Place de la Concorde where they remained until 1984 when they were replaced by casts.

Above these figures and also by Coysevox are the *Seine*, allegorized as a god, alongside the *Marne, Neptune,* and *Amphitrite.* Two other groups inspire admiration for their audacious conception and skillful execution: Pierre Lepautre's *Paetus and Arria* (1691–1695), based on a model by Jean Théodon, and his *Aeneas Carrying his Father Anchises* (1697), based on a model by François Girardon.

The Cour Puget sculptures range from the end of the seventeenth century to the mid-nineteenth century. The bronzes on the lower terrace, taken from the Place des Victoires in Paris, are the work of Martin van den Bogaert, known as Desjardins. His *Prisoners in Chains* (1679) symbolizes the nations subjugated by the Peace of Nijmegen. Pierre Puget's most celebrated sculptures are displayed on the mid-level terrace: *Milo of Croton Attacked by a Lion* (1670-82), and *Perseus Freeing Androm-eda* (1684), with its baroque* composition and effects of contrast.

View of the Cour de Marly with Antoine Coysevox's horses. Architects Ludovico Visconti and Hector Lefuel, 1852–57.

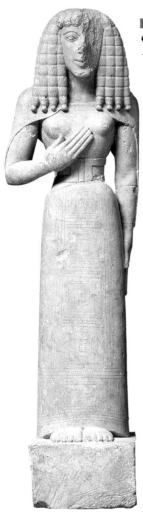

"Dame
d'Auxerre," also
known as the
Auxerre Goddess,
c. 630 B.C.
Limestone,
29½ ins
(75 cm).

■ "Dame d'Auxerre"

At the beginning of the twentieth century, this small statue was found in the reserve collection of the provincial museum in Auxerre. It is exceptionally well-preserved, but its origin is a mystery. Carved from soft limestone, the young female figure stands straight and somewhat stiffly, firmly supported by her two feet, visible at the bottom of her long skirt. Judging from the traces of red on her chest, she was once brightly painted. The triangular face is framed by thick hair which falls symmetrically onto the shoulders. The lips turn up in a faint smile. The figure wears an embroidered tunic, cinched at the waist by a large belt which molds the cylindrical body, emphasizing the round breasts. The shoulders are covered by a cape. The right hand is drawn to the chest; the left is at her side.

Its "Daedalic" form is indicative of Cretan art from the seventh century B.C. Named after Daedalus, the mythic inventor of sculpture, the Daedalic style, influenced by Egyptian and Near-Eastern models, is an austere step in the direction of the great periods of archaic and classical Greek sculpture.

■ David (Jacques Louis)

David (1748-1825) was a painter of historic scenes who took his inspiration from great models of antiquity, aiming to extol civic virtue and moral values in an era troubled by revolutions. His sweeping, powerful compositions and his masterful drawing influenced all the artists of his century. David studied in the workshop of Joseph-Marie Vien. He was awarded the Rome Prize after four attempts, and spent five years in Italy. Returning to Paris in 1780, he was elected a member of the Academy. David returned to Rome in 1784 where he painted *The Oath of the Horatii*. This drama from antiquity, rendered by the play of bold lines and a rigorous composition, won David recognition as the uncontested master of neoclassicism. The lesson is exemplary. The painter celebrates the virtues of heroism, courage, and patriotism. Active alongside Robespierre in the French Revolution, he used his art to serve the national cause, bearing witness to contemporary events, such as in the *Death of Marat* (1793). He also created psychologically acute portraits of society figures and other contemporaries. Upon the arrest

of Robespierre in 1794, David was put in prison. He continued to paint in spite of everything, and completed *The Intervention of the Sabine Women* in 1799. Napoleon offered David his protection and named him his first court painter in 1804. The Emperor's coronation is immortalized by the painter in a scene of panoramic proportions, *Coronation of Napoleon I, December 2, 1804*. After the fall of Napoleon, David left Paris for Belgium, where he founded a studio in Brussels.

Delacroix (Eugène)

In the words of Baudelaire, Delacroix (1798–1863) is the "head of the modern school."

Focusing on imagination, the artist conveyed a personal interpretation of the great tradition of European painting and opened the way to the future. Color, taking precedence over drawing, enriches his compositions, determining their content and expression.

Starting at the Ecole des Beaux-Arts in 1817, Delacroix became friends with Gros and Géricault. His work was exposed for the first time in the Salon of 1822 with *Dante's Ship*, which was purchased by the State. In 1824, Delacroix presented the *Massacres at Chios* which recounts an episode of the recent war between the Greeks and the Turks. In 1827 he showed

Jacques Louis David, *The Intervention of the Sabine Women,* 1799. Oil on canvas, 12 ft 7½ ins × 17 ft 1½ ins (3.85 × 5.22 m).

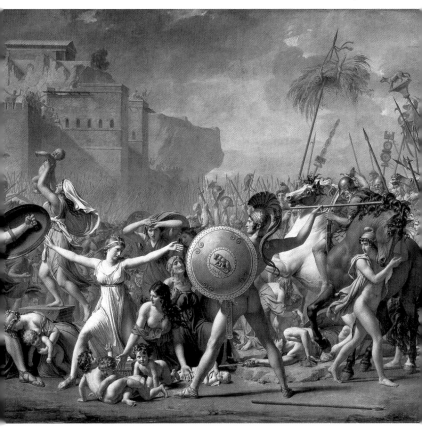

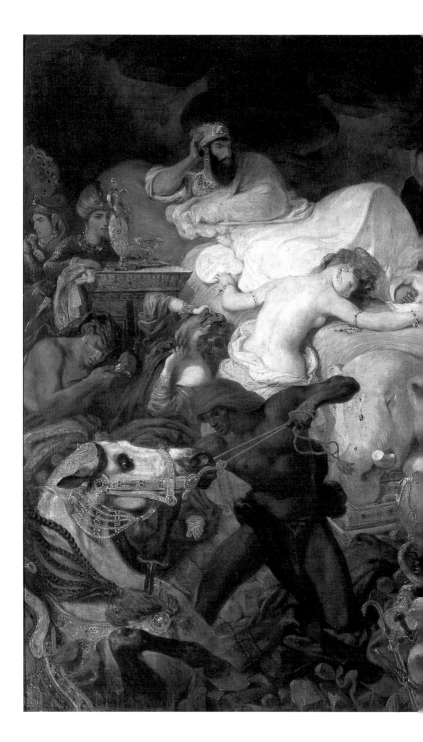

Eugène Delacroix, *The Death of Sardanapolis,* 1828.
Oil on canvas, 12 ft 10¼ ins × 16 ft 3¼ ins
(3.92 × 4.96 m).

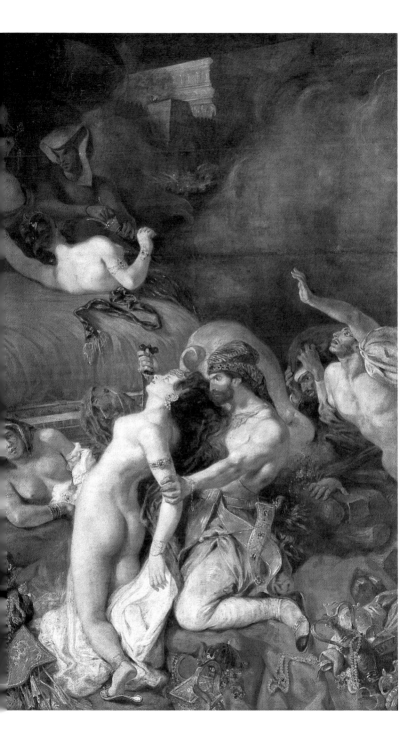

The Death of Sardanapolis. This canvas dispenses with all the conventions of perspective, composition, and representation, with color given prominence in a red and gold diagonal which establishes the painting's unity. With this vehement expression of disorder, eroticism, and death, Delacroix positioned himself at the forefront of the Romantic* movement.

In 1832, Delacroix set sail from Toulon with the French Delegation to the Sultan of Morocco, visiting Spain and Algiers. He was deeply impressed by the North African light, and filled notebooks with drawings and watercolors, which later served as precious source material. The State commissioned monumental decorative works for the House of Deputies and the Senate, and frescoes for the Church of Saint-Sulpice which the artist completed two years before his death. Delacroix also proved a talented writer. His *Journal*, begun in his youth, is a passionate account of his era.

The Louvre in 1380 (view, from above). R. Mounier and S. Polonovski. Scale 1/1000.

■ DONJON

The fortress erected on the orders of King Philippe Auguste around 1200 was a rectangle 78 by 72 meters (approx. 234 by 216 feet) in size incorporating ten round towers at the angles and in the middle of each side. Two entries, one to the east towards Paris and the other on the south along the Seine, allowed access to the fort. In the center rose the donjon, or "Great Tower," a symbol of royal power. It formed a perfect cylinder approximately 49 feet (15 meters) in diameter and 98 feet (30 meters) in height. Surrounded by a moat, it was reached by drawbridge, and housed archives, the treasury and the occasional prisoner. François I ordered the donjon's demolition in 1528. Recent work on the Louvre provided the occasion for major excavations which in 1985 uncovered the medieval Louvre with its foundations and its donjon.

The Saint-Louis Room was probably low-ceilinged in the days of Philippe Auguste. It was renovated and fitted with rib vaulting in the mid-eighteenth century. Charles VI's gold helmet, on exhibit in a display case, was found at the bottom of the donjon pit.

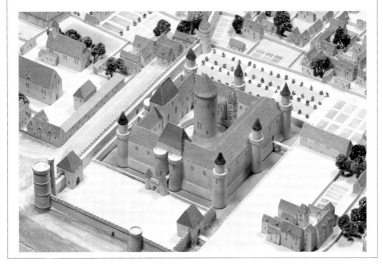

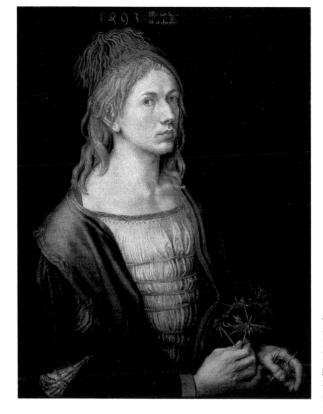

Albrecht Dürer,
Self-portrait,
1493.
Parchment
glued on canvas,
25¾ × 17¾ ins
(65.5 × 45 cm).

Dürer (Albrecht)

Albrecht Dürer (1471–1528) trained as a goldsmith in his father's workshop. This apprenticeship proved essential for the future draftsman and printmaker. In 1490, after studying painting in the studio of Michael Wolgemut, Dürer set forth on a four-year journey, likely traveling to Colmar where he hoped to meet the great engraver Martin Schongauer, and to Holland to study with van Eyck and van der Weyden. Moving in Humanist circles, Dürer primarily produced engravings and drawings. In 1493, he painted his first *Self-portrait* which attests to his awareness of his own great talent. He set out for Italy in 1494 and visited Venice, where he discovered in Venetian Renaissance painting a regenerative source of inspiration. Returning to Nuremberg at the age of twenty-five, Dürer

opened his own studio. His technical mastery and lively imagination brought him admiration for his *Apocalypse* series. Fleeing the plague in 1505, Dürer returned to Venice, where he was commissioned to paint *Virgin of the Rose Garlands* (1506), which is impressive for its unity of color and clarity of composition.

From 1510 on, Dürer devoted himself mainly to engraving, marked with a new spiritual depth *(Melancholy).* Prints of his work were sold throughout Europe, influencing all the Western artists of his time. At the end of his life, Dürer turned to writing treatises on painting which were to be used by generations of artists.

With his genius and open-mindedness, Dürer achieved a synthesis between the vocabulary of the Italian Renaissance and the Flamboyant Gothic world of his origins.

Ebih-il, Superintendent of Mari

Ebih-il, Superintendent of Mari, c. 2400 B.C. Alabaster and lapis lazuli, 20½ ins (52 cm).

The Sumerian civilization was founded circa 3000 B.C. in lower Mesopotamia. It spread widely throughout the upper-Tigris and mid-Euphrates regions, particularly to the royal city of Mari, located on the border of present-day Iraq and Syria. Since 1933 excavations have been uncovering the richness of this site. In the temple of Ishtar, goddess of love and war, numerous worshippers deposited votive offerings in their own likeness. The back of the ex-voto of Ebih-il bears the inscription: "Statue of Ebih-il, the Superintendent, in honor of warrior Ishtar." The figure's intense gaze is reinforced by shell and lapis lazuli inlay. The precious lapis lazuli, imported from the easternmost reaches of Afghanistan, provides a marked contrast with the local, perfectly polished alabaster which dominates the piece with its air of refined elegance. A faint smile animates the face of Ebih-il who is shown seated with his hands joined in prayer. He is dressed in Sumerian style with a *kaunakes* skirt comprised of wool strands.

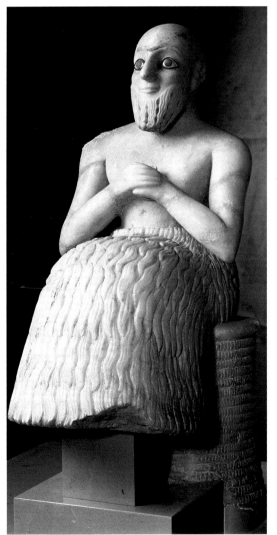

Fouquet (Jean)

Jean Fouquet (c. 1415/1420–1480) is the greatest French painter of the fifteenth century. Only a few facts are known relative to his training and the stages of his career. He made a decisive journey to Italy in 1446, and eventually settled in Tours, France, where the king and his court were often in residence. During his stay in Italy, Fouquet assimilated the Italian painters' monumental conception of space, and introduced the Renaissance spirit into his own compositions, while remaining attached to the realism of Flemish art. In his portrait of *Charles VII, King of France,* Fouquet invented a new image of royal majesty through the imposing construction of space and geometric forms, while

+ LE TRESVICTORIEVX ROY'DE FRANCE +

+ CHARLES + SEPTIESME + DE CE NOM +

the king's face remains faithful to its model. Fouquet undertook major projects for Etienne Chevalier, the State Treasurer, including the *Melun Diptych*. His own likeness in one of the enamel medallions that were part of this work's original frame is the first known self-portrait by a French artist. A great painter of illuminated manuscripts, Fouquet illustrated the *Great Chronicles of France*, a history of the French monarchy, for King Charles VII. Fouquet's masterpiece is the *Book of Hours of Etienne Chevalier* (1452–60), where his scenes of daily life or lives of saints in luminous landscapes convey an palpable sense of vitality.

Fragonard (Jean Honoré)

Fragonard (1732–1806) was awarded First Prize by the Academy of Painting at the age of twenty, studied at the Royal School, and set out for the French Academy in Rome in 1756. In the Summer of 1760, under the protection of his patron the Abbot of Saint-Non, Fragonard completed a dazzling group of drawings of the Estes Villa gardens: shimmering landscapes and spontaneous, care-free genre scenes. Back in Paris in 1765, he presented a history painting, *Coresus and Callirhoë* at the Salon. It was a stunning success, purchased by the king,

Jean Fouquet, *Charles VII, King of France,* c. 1445–50. Oil on wood, 33¾ × 28 ins (86 × 71 cm).

Jean Honoré
Fragonard,
Denis Diderot,
c. 1769.
Oil on canvas,
32 × 25½ ins
(81 × 65 cm).

French school,
*The Galerie
d'Apollon,*
c. 1880.
Oil on canvas,
21¾ × 18 ins
(55 × 46 cm).

and Fragonard, lionized by the critics, was made a member of the Academy.

But Fragonard turned his back on all the honors, painting neither a reception piece for the Royal Academy, nor fulfilling royal commissions. He dedicated himself to a private clientele, creating such light-hearted, flirtatious scenes as *The Swing* (1767). With a free, rapid, and energetic brush stroke, Fragonard did an exceptional series of fourteen "Fantasy figures" in Spanish costumes. Some of them are of famous personalities, including Diderot, while others evoke history or music. Fragonard was

sought after for his decorative work, and completed panels for the Louveciennes residence of Madame du Barry. But popular taste turned, and the work was removed. Under attack, Fragonard dejectedly left Paris for a second journey to Italy, returning with a stunning series of landscape drawings. In Paris again at the end of 1774, Fragonard's reputation remained diminished, but his style was regenerated. His palate became lighter and more harmonious in tone, with a touch of renewed refinement and a technique which, without sacrificing its free brushwork, is reminiscent of the Dutch masters.

■ GALERIE D'APOLLON

The Galerie d'Apollon (Apollo Gallery) is located on the first floor above ground level of the Petite Galerie. Built by Henri IV, it was destroyed by fire in 1661. Louis XIV had it rebuilt by Louis Le Vau and placed Charles Le Brun in charge of its decoration. The myth of Apollo, god of the sun, was selected as the theme, an analogous association of the French king with the god. The ambitious project was not completed until two centuries later. The barrel vault is divided into eleven compartments decorated with painted canvases framed in gilt stucco. Le Brun himself painted the *Triumph of Neptune.* The sculpted figures and stucco work was done by François Girardon, Thomas Regnaudin and the Marsy brothers in 1663 and 1664. Girardon's handsome Neptune statue dominates the gallery from the south side.

After 1678, the Academy of Painting and Sculpture moved in. Copyists would work there, and drawings were exhibited. Félix Duban began restoration work in the nineteenth century, and the gallery was finally finished in October 1851, with the installation of Delacroix's* *Apollo Defeating the Serpent Python* in the central compartment—a fine accompaniment to Le Brun's decorative scheme. Sealed off behind seventeenth-century iron gates taken from the chateau Maison-Laffitte, today the Galerie d'Apollon houses the crown jewels. The *Regent,* a 140-carat diamond discovered in India and cut in England, was bought by the Regent Philippe d'Orléans for the French Crown. A large pink ruby, the *Côte de Bretagne,* belonged to Anne de Bretagne. The *Sancy* was in the possession of Nicolas Harlay de Sancy, Superintendent of Finances preceding Sully, and bought by Mazarin in 1661. The coronation crowns of Louis XV (1722) and the Empress Eugénie (1853) are displayed alongside Sardinian agate and rock crystal vases.

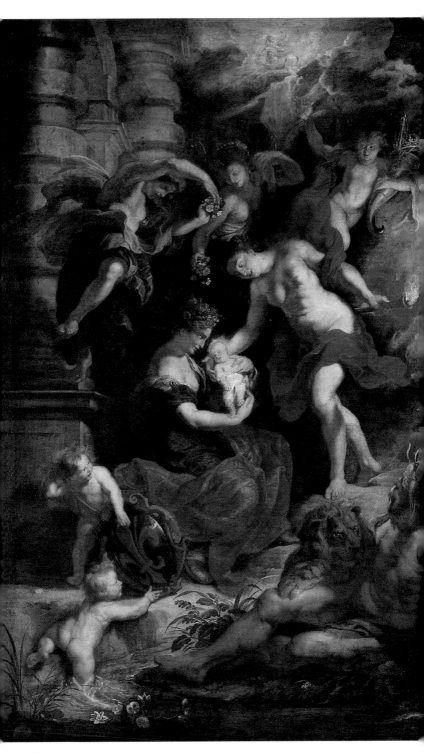

Wife of Henri IV, Queen Marie de' Medici became the regent of France following the king's assassination in 1610. In 1621 she asked Rubens, whose reputation had spread worldwide, to paint two galleries of her new Luxembourg Palace with a series depicting first her own, and then the late king's, life stories. After sending ahead sketches, Rubens arrived in Paris on May 24, 1623, with nine canvases already begun in his Antwerp studio, intending to finish them in situ. The final series of paintings of the *Life of Marie de' Medici*, comprised of twenty-four canvases painted primarily by the master himself, was completed in 1625. The canvases were brought to the Louvre and installed in this gallery specially renovated to accommodate them. At the Luxembourg Palace, windows between the paintings served to light them; at the Louvre, illumination is from above. The gods and goddesses descend from Olympus at the birth of the queen to follow her throughout the events of her life. They glorify the triumphs of her rule, and sustain her in times of adversity and conflict. After her birth in Florence on April 26, 1573 (painting II), Marie de Medici learns to read in the presence of the god Apollo, under the attentive eye of the three Graces (painting III). Disembarking in Marseilles on November 3, 1600, she is greeted by France (painting VI) before continuing on to Lyons where her marriage to Henri IV takes place (painting VII). After the birth of Louis XII on September 27,1601 (painting VIII), Rubens illustrates the death of Henri IV, the regency bestowed upon the queen (painting X), and her harmonious reign (painting XV), without forgetting the trying occasion of the flight from Blois in February of 1619 (painting XVII).

Rubens unreservedly employed all of his genius and talent in the queen's service, creating the ideal and triumphant portrait of the woman of power, her role in history, and her majesty. The compositions, dynamic and static by turns, move the viewer's eye from one to the next in a seemingly endless flow. In these sumptuous and monumental scenes, the light has an unreal quality which emphasizes the grandeur of the figures, the beauty of the nudes, and the richness of red and gold tonalities. The sweeping energy and movement which infuses each panel makes this series one of the great masterpieces of baroque* art.

Peter Paul Rubens, *The Birth of Marie de' Medici in Florence*, 1621–25. Oil on canvas, 12 ft 11 ins × 9 ft 8 ins (3.94 × 2.95 m).

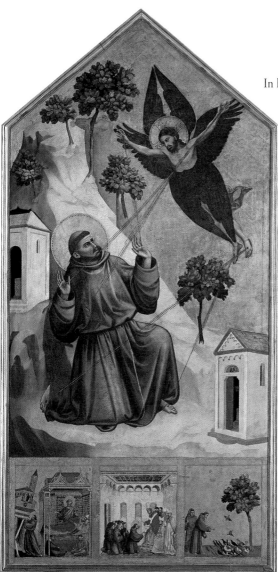

In his unique new manner of representing figures, Giotto can be seen to have already broken with the Byzantine tradition. His influence spread to Florence and Rome. He was summoned to Rimini, then Padua, where he decorated the Enrico Scrovegni Chapel. The two fresco cycles Giotto painted between 1302 and 1305 are considered his masterpieces. Rejecting contemporary conventions of representation, the artist introduced the notion of space into scenes where the figures seem to be in motion. Imbued with a breathtaking monumentality, these figures emphasize the dramatic intensity of the sacred stories they recount.

Giotto's completion of the Padua cycle was followed by a period of mature, intensive production. In Florence, he painted the *Scenes from the lives of St. John the Baptist and St. John the Evangelist* in the Peruzzi Chapel of the Santa Croce Church, as well as the *Scenes from the Life of St. Francis* in the Bardi Chapel. Between 1328 and 1333 Giotto resided in Naples in the service of Robert d'Anjou. Upon returning to Florence, he was named chief artist of the bell tower that bears his name, but died before the structure could be erected.

The revolutionary achievement of Giotto's art would not be truly understood until a century later, by the painter Masaccio.

Giotto di Bondone, *The Stigmatization of Saint Francis,* c. 1300.
Oil on wood, 5 ft 4 ins × 3 ft 8 ins (1.63 × 1.13 m).

◾ Giotto di Bondone

The painter Cimabue supposedly discovered the young Giotto (c. 1266–1337) in the process of sketching his flock of sheep. The absence of documentation pertaining to him before 1300 make his career difficult to follow, but Giotto was probably placed in the workshop of a local painter, and the frescoes in the Upper Basilica of St. Francis in Assisi are attributed to his early style.

■ GRANDE GALERIE

The Grande Galerie was built during the reign of Henri IV between 1595 and 1608. 1509 feet (460 meters) in length, it joined the Louvre Castle to the Tuileries Palace and was initially referred to as the "gallery along the water." Reserved for royal receptions, it was used by the king in the Ecrouelles (scrofula) Ceremony, in which the monarch was supposed to cure the afflicted by a laying on of hands. From 1697 to 1777 the Galerie served as an archive for relief maps of the kingdom's strongholds (today at the Invalides), before the idea of installing a royal museum took shape. Several architects and painters took part in the plans for converting the space. The painter Hubert Robert* was ahead of his time in proposing overhead lighting and protruding arcs on the lower vaulting to break up the expanse. The space was opened to the public on August 10, 1793. Paintings were hung in the barrel-vaulted space, the larger works above and the smaller pieces below. Charles Percier and Pierre Fontaine renovated the gallery between 1805 and 1810, adding bays between the columns, so pictures could be hung by schools. In 1856, Hector Lefuel opened the barrel vault to provide improved lighting, in response to visitors' complaints about the poor-quality window illumination. Then he reduced the gallery's length by a third to create the Flore Wing and the Sessions Pavilion. Today the Grande Galerie measures 945 feet (288 meters) and presents Italian painting from the fifteenth, sixteenth and seventeenth centuries.

Hubert Robert, *Plan for the Grande Galerie Renovation*, 1796. Oil on canvas, 3 ft 8 ins x 4 ft 8¼ ins (1.12 × 1.43 m).

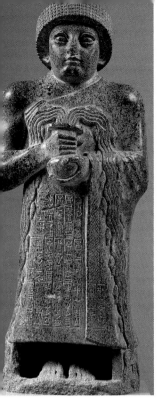

Gudea With Overflowing Vase

Sumer was rediscovered in the nineteenth century in the course of archeological excavations on the site of Telloh, in southern Iraq. Statues and inscriptions attest to the revival, after a long period of decline, of a local and powerful dynasty at the head of the state of Lagash in Mesopotamia during the second half of the twenty-second century B.C. The most illustrious ruler, Gudea, was a pious prince who undertook the construction of numerous temples. His religious devotion is evidenced by the number of extant statues depicting the sovereign in the act of worship. His name is inscribed on several statues, including twenty works found in the excavations. The prince is represented sitting or standing, praying with joined hands. He wears a toga which bares the right shoulder, and a royal wide-brimmed fur head covering. The statues, generally made of diorite, a hard stone imported from Oman, were placed in the sanctuary of the town of Telloh. One statue depicts Gudea holding a small overflowing vase. This work comes from the temple of the god Ningisida and the goddess Geshtinanna, to whom the prince proffers the vase, a symbol of fertility. The inscription on his garment is dedicated to the goddess, whose name means "heavenly vine." Gudea's features were idealized by the artist to emphasize the prince's image of steadfast piety.

Gudea with Overflowing Vase, Telloh, ancient Girsu, c. 2150 B.C. Calcite, 24½ ins (62 cm).

Houdon (Jean Antoine)

Jean Antoine Houdon (1741–1828) dominates the history of later eighteenth-century French sculpture. He was "the" portraitist of famous figures in the arts, letters, politics, and science. Awarded the Rome Prize in 1761, Houdon remained in Italy for three years, soaking up the classical influence. Returning to Paris in 1768, he presented a plaster version of a graceful,

Jean Antoine Houdon, *Alexandre Brongniart, Aged Seven Years,* 1777. Terracotta, 12½ ins (32 cm).

fully
n u d e
*Diana the
Huntress* at the
Salon of 1777. The
*Funerary Monument to the
Count of Enery* (1781) displays
Houdon's interest in Neoclassicism.* The artist's lasting international reputation is due above all to the portraits of his contemporaries. He shows a rare genius for seizing his models' likeness and psychology, as well as for conveying their social standing. Houdon's masterpieces include *Denis Diderot* (1771), *Benjamin Franklin* (1778), *George Washington* (1786), which he journeyed to America to execute, and *Jean-Jacques Rousseau* (1778). He worked in terracotta, marble and bronze with equal mastery, and varied his materials as well as presentation, for instance by switching hairstyle and costume from classical to French folkloric styles according to his clients' tastes. In his informal and personalized portraits of children, Houdon captured the freshness and delicacy of childhood, as demonstrated in the renowned *Children* of the architect Brongniart, a friend of the artist.

▦ Ingres (Jean Auguste Dominique)

Ingres (1780–1867) began drawing in childhood under the tutelage of his father, a painter and sculptor. He was accepted to the Royal Academy of Toulouse in 1791, at the age of eleven. At the age of seventeen, Ingres went to Paris, where he studied in David's studio. He received the Rome Prize and his first commissions in 1801. Five years later in Rome, Ingres found inspiration in the Vatican Raphael rooms, doing portraits and nudes in which the anatomical stylization attests to

Jean Auguste Dominique Ingres, *The Turkish Bath*, 1862.
Canvas on wood, diameter 3 ft 6½ ins (1.08 m).

KAROMAMA

Karomama,
c. 850 B.C.
Bronze inlaid
with gold,
silver, and
electrum,
23¼ ins
(59 cm).

Ingres' mastery of draftsmanship. When *Jupiter and Thetis* (1811) was sent to Paris it incited public mockery, and Ingres was hurt by the misunderstanding of his work. He was finally given a commission for the *The Vow of Louis XIII*, depicting the king praying before the Virgin and Child. This canvas, with its references to Raphael's Madonnas, was universally acclaimed at the Salon of 1824 as the height of classical art. Ingres opened a Paris studio and painted the *Apotheosis of Homer* for a Louvre ceiling. The 1832 masterpiece *Louis-François Bertin* marks the artist's return to the portrait genre. The imposing image of this newspaper magnate came to symbolize the triumph of the French liberal bourgeoisie. In 1834 Ingres became Director of the Villa Medici in Rome, where he remained for seven years.

Upon returning to Paris, Ingres was commissioned to decorate the walls of the Castle of Dampierre as well as the Paris Town Hall, where he chose as his subject the *Apotheosis of Napoleon*. He devoted the energy and powers of his limitless imagination to *The Turkish Bath*, the glorious masterwork of his final years.

■ Karomama

"I am bringing the Louvre the most beautiful bronze ever discovered in Egypt. It is a statue at least two feet high of the wife of King Takelothis from the Twenty-second Dynasty. This little masterpiece is a marvel for work and execution." Thus wrote Jean-François Champollion in 1829 before his return to France from Egypt. This statue of Karomama, the divine consort or "adoratress" of Anum, is indeed one of the finest Egyptian bronze pieces known.

A sense of feminine perfection is exuded by the elegant form garbed in a narrow pleated dress decorated with feathers, with its delicate features crowned by the royal cobra. The figure wears a massive neckpiece clasped behind by a heavy closing inscribed in the name of "the beloved of Mout, Karomama." Her hands are believed originally to have held two sistrums which she rattled for the god. The crown, probably made of feathers, is also missing.

In the period of economic and political crisis during the Third Intermediary Period, the relations between gods and humans changed. This included the rise of a priestly class exclusively concerned with temple life. The divine adoratress, a vestal virgin,

dedicated her existence to the god Amun, without however renouncing worldly comforts and royal privileges. She is therefore represented as a spiritual sovereign who probably played an important political role.

Le Brun (Charles)

Le Brun (1619–1690) was the dominant figure in the history of French art for over twenty years. Trained in the workshop of Simon Vouet, he went to Rome in 1642 in the company of Poussin. Under the patronage of Chancellor Séguier, he returned to Paris where he rapidly expanded his clientele, building a reputation as an artist attentive to the decorative tastes and dictates of his era. He was one of the original founders of the Royal Academy of Painting in 1648, and decorated churches and townhouses. Le Brun's portrait of Chancellor Séguier dates from around 1655. The work is a majestic dramatization of the sitter's dignity, elegance, and grandeur. Le Brun's talent for conceiving prestigious and grandiose decorative ensembles was established with his work at the castle of Vaux-le-Vicomte (1658–61), at the time owned by Fouquet. Louis XIV made Le Brun the director of the Gobelins Royal Tapestry Works, and named him first painter to the king in 1664. First with the Galerie d'Apollon* at the Louvre, and then even more so at Versailles, this authoritarian and prolific artist imposed the grandeur and coherence of the "Louis XIV Style" with a consolidation of all the arts. The decoration of the demolished Escalier des Ambassadeurs (Ambassadors' Staircase) in the Galerie des Glaces (Hall of Mirrors) (1679–84) at Versailles, along with the salons of War and Peace (1685) glorified absolute monarchy and influenced all the courts of Europe. In the

Charles Le Brun, *Chancellor Séguier,* c. 1655. Oil on canvas. 9 ft 8 ins x 11 ft 8½ ins (2.95 × 3.57 m).

same vein, the four epic poems of the "History of Alexander" (1665–73) serve to associate Louis XIV with the great hero in lyrical and grandiloquent battle scenes reminiscent of Raphael's Vatican frescoes.

Le Nain Brothers

The three Le Nain brothers—Antoine (c. 1595/1600–1648, Louis (c. 1595/1600–1648) and Mathieu (1607–1677) came to Paris around 1629 and met with overnight success. They were among the first members of the Royal Academy of Painting in 1648. The brothers are believed to have worked collectively. Several of their paintings are signed, but they never include a first name. Their production is unified by its subject matter and realism. On the strength of their religious paintings (many of which have been lost) and rare mytho-logical subjects the Le Nain brothers won such important Parisian commissions as the decoration of the Chapel of the Virgin at the Church of Saint-Germain-des-Prés, destroyed during the French Revolution. Their portraits, much acclaimed by the sitters, also brought them fame: they specialized in the Dutch tradition of group portraiture which they transformed into genre scenes, for example *The Smokers' Den* (1643).

It is the numerous scenes featuring peasants that assure the Le Nain brothers' lasting importance. These canvases feature powerful and often highly contrasted delineation, simple composition, a focus on the subjects' gaze, and a palette dominated by brown and gray tones with some notes of color. Far from being picturesque or burlesque, the world of these peasants is solemn and silent.

Le Nain,
Peasant Family,
1642.
Oil on canvas,
3 ft 8½ ins ×
5 ft 2½ ins
(1.13 × 1.59 m).

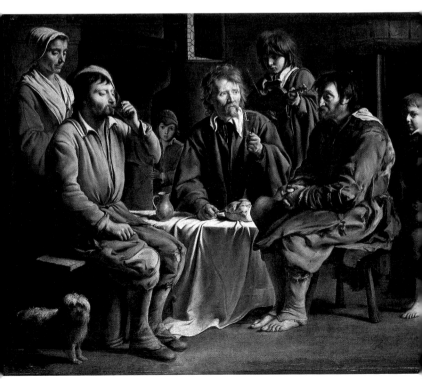

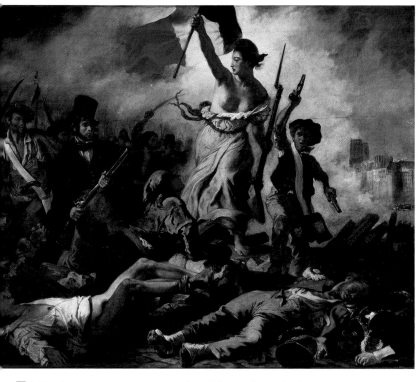

■ Liberty

When Charles X ascended to the throne in 1825 upon Louis XVIII's death, he revived an Ancien Regime tradition by holding his coronation in Reims. Very soon thereafter he implemented reactionary and authoritarian policies. His Saint Cloud Ordinances of 1830, eliminating freedom of the press and modifying electoral laws, triggered the revolution. The people of Paris rose up against him on July 27, 28 and 29, 1830. These three days, known as the *Trois Glorieuses*, included Charles X's abdication in favor of his grandson, Count Chambord. Hector Berlioz described the fervid atmosphere of the moment in his *Memoirs*: "I will never forget Paris's special character during those famous days. The stunning bravery of children, people's enthusiasm, the excitement of women of the street, the sad resignation of the royal guard, and the singular pride that

workers felt, as they said, in being masters of the city without having stolen anything from anyone."

When Eugène Delacoix painted *Liberty Leading the People*, he sought both to celebrate that revolution and to affirm his status as a modern artist engaged in the events of his time. He decided to represent the events of July 28, the second day of the *Trois Glorieuses*, when the insurrection took a decisive turn. Everyone knew the barricades as a representative symbol of revolution; some 4,000 barricades went up in Paris during the three day revolt. In the painting, a young woman wearing a republican hat, with the tri-color flag in her right hand and a rifle in her left, leads a group of revolutionaries over a barricade, amid those fallen in battle. The flag can also be seen in the background, flying from a tower of Notre Dame. Gloriously emerging from the rifle smoke,

Eugène Delacroix, *Liberty Leading the People*, 1830. Oil on canvas, 8 ft 6¼ ins × 10 ft 8 ins (2.60 × 3.25 m).

Donatello,
*Madonna and
Child*, c. 1440.
Polychrome
terracotta,
3 ft 4 ins ×
29 ins (1.02 ×
0.74 m).

her breast exposed and her confidence strong, this woman is the image and symbol of Liberty. The boy beside her brandishing pistols wears a black velvet student's beret, incarnating youth in revolt. Thirty years later Victor Hugo immortalized him again, giving him the name of Gavroche in *Les Misérables*. *Liberty Leading the People* was accepted by the jury of the Salon of 1831, and was displayed at its opening, on May 1.

■ Madonna and Child

Half-figure bas-reliefs of the Madonna holding baby Jesus are one of the most frequent subjects of fifteenth-century Italian

sculpture. Donatello (diminutive of Donato di Niccolò di Betto Bardi, 1386–1466) brought changes to the traditional iconography in this fine example. Depicted in dazzling color within the gilded frame, Jesus appears to turn away from his mother, as if attempting to spare her the suffering that lies ahead. The Virgin looks at her child with a tragic and troubled expression. Emotional power unites the entire composition played out before a golden curtain.

Depictions of the *Madonna and Child* punctuate Donatello's career. Taking his inspiration in the art of antiquity, this Florentine sculptor moved beyond the

art of his era to a compelling realism expressive of human drama. His innovations would be developed by the great Renaissance masters.

of Venetian artists. In 1456, he was commissioned to paint the "Pala" of San Zeno in Verona. This immense altarpiece, comprised of six panels, was not com-

Mantegna (Andrea)

Mantegna (1430/1431–1506) began an early apprenticeship in Padua in the workshop of Francesco Squarcione. In 1455, he completed frescoes of the life of St. James and St. Christopher for the Eremitani Church. Though the building was largely destroyed during World War II, the conception and severe grandeur of the remaining portions of Mantegna's work reveal the artist's interest in Greek and Roman antiquity, his study of perspective, upheld by precise and skillful drawings, and his overall technical mastery. In 1453 Mantegna married the sister of Gentile and Giovanni Bellini, thereby becoming a member of the reigning family

pleted until 1460. It was dismantled and transported to France in 1797. The three main panels were subsequently returned to the basilica in Verona; the predella paintings remained in France. The *Crucifixion* is on display at the Louvre; *Christ in the Garden of Olives* and the *Resurrection* are in the collection of the Tours museum. At the height of his artistic powers, Mantegna structured his compositions into a grandiose vision of antiquity. Summoned by Ludovico II de Gonzaga, Mantegna was named the official painter to the Court of Mantua from 1459 until his death. The *Matrimonial Chamber* of the Ducal Palace, completed in 1474, is highly innovative in its

Andrea Mantegna, *The Crucifixion,* c. 1456–59. Oil on wood, 30 × 37¾ ins (76 × 96 cm).

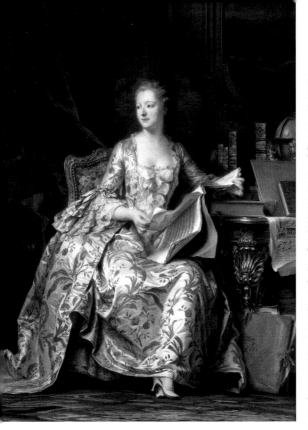

to the right of the image which bears the inscription *Pompadour sculpsit.* Pastel was used early on by Leonardo da Vinci who designated it "dry coloring." The colored powder, with its more than 1,600 hues, was brought to France from Italy. This supple medium allows for blending, erasure, and corrective approaches as well as for the layering of colors. Pastel was highly popular in eighteenth-century France. Some artists, including Delatour, worked exclusively in pastel, and others use the medium for sketches and portraiture.

Delatour was made a member of the Academy in 1746. He became the portraitist of the royal family and major court figures, excelling at delicately conveying the psychology of his models, and registering passing emotions. For official portraits like the *Marquise*, Delatour would draw the head from life on a piece of circular paper which he later incorporated into the rest of the composition. Such dimensions are rare in pastel work, but Delatour's virtuosity and mas-

Maurice Quentin Delatour, *Portrait of the Marquise de Pompadour,* 1752–55. Pastel on blue-gray paper, 5 ft 9¾ ins × 4 ft 3½ ins (1.77 × 1.31 m).

all-encompassing illusionistic decoration, including an oculus that seems to open onto the sky. Mantegna's work on perspective culminates in the foreshortened view of his *Dead Christ.* An artist of great originality, Mantegna's legacy of powerfully learned and solemnly grandiose works was to influence all the artists of northern Italy.

■ Marquise de Pompadour

This pastel of unusual size and quality took the artist Maurice Quentin Delatour (1704–1788) three years of work to complete. Madame de Pompadour is shown seated in her salon, surrounded by objects symbolic of her role as patroness of the arts: literature, music, astronomy, engraving. The Marquise herself practiced etching, as attested by the plate

tery permitted him to render the silk brocades, lace, and velvet of the dress with equal perfection, in keeping with his refined modeling of the face and the delicate articulation of the grain of the skin.

■ Maximilian's Hunt

Acquired by Louis XIV in 1665, this hanging, described as "the Emperor Maximilian's twelve hunting expeditions," is one of the world's greatest tapestries. According to the contract drawn up between a businessman and two merchants, it was woven in Brussels around 1533. The work is made up of twelve pieces whose scenes depict hunting episodes, one for each month of the year. A medallion in the middle of the upper border indicates the corresponding sign of the zodiac. Bernaert Van Orley (c. 1488–1541) designed the group, composing sweeping and balanced scenes where the action takes place against a grandiose backdrop in keeping with the Renaissance's new ornamental views. The series begins in *March*, the first month of the year of the calendar used in Brussels until 1575. The neighboring town and forests provide a majestic setting for the hunt. *April* shows the dogs taking off after the game. *May* and *June* detail the hunters' preparation and banqueting. The stag hunt begins in earnest in *July*, with *August*, *September*, and *October* covering the letting loose of the stag, the scramble in a pond, and the death of the quarry. *November*, *December*, and *January* illustrate a boar hunt, and *February* ends the adventures with the hunters' homage to King Modus and Queen Ratio, allegorical figures from a fourteenth-century hunting treatise. The Brussels masters' exceptional weaving is faithful to the quality of Van Orley's cartoons. The colors underline the scenes' monumentality, and the silver and gold threads provide sumptuous brilliance to this outstanding tapestry group.

Bernaert Van Orley, *Maximilian's Hunt, Month of March*, 1531–33. Tapestry, silk, wool, silver and gold thread, 14 ft 6¾ ins x 9 ft 10 ins (4.44 × 6.05 m).

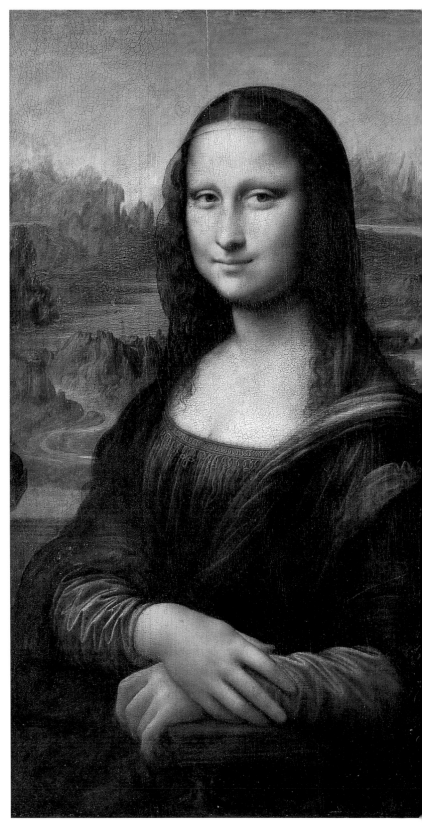

■ MONA LISA

An inventor, draftsman, mathematician, engineer, architect, urban planner, and last but not least painter, Leonardo da Vinci (1452-1519) is the ultimate symbol of Renaissance Humanism, marking the high point of his outstanding era with his personal genius and artistry. Leonardo was apprenticed in Florence to the painter Andrea del Verrocchio, and went to the court of Ludovico Sforza in Milan in 1482. He remained in Milan for twenty years, working on a project for an equestrian statue, experimenting with hydraulics, and conceiving sumptuous court celebrations. There, he completed the *Last Supper* for the refectory of Santa Maria delle Grazie in 1495. In 1499 Leonardo returned to Florence, where in 1503 he began the renowned portrait of *Mona Lisa*, also known as *La Gioconda*. Around 1510 Leonardo's presentation of *The Virgin and Child with St. Anne* created a sensation because of the way its monumental arrangement of figures in a pyramid shape is brought to life through the illusion of slight rotation. He was commissioned to paint a large fresco for the Grand Councilor's Room at the Palazzo Vecchio, *The Battle of Anghiari,* to commemorate the victory of the Florentines over the Pisans. This fragile work did not withstand the ravages of time, and is known only through drawings and copies. In 1517 Leonardo went to France on the invitation of François I, who named him "First Painter, Architect, and Mechanic to the King." Leonardo brought with him *Mona Lisa,* which the monarch purchased. The great artist died in Amboise, France, in 1519.

On August 21, 1911, *La Gioconda* was stolen from the Louvre by the Italian Vincenzo Peruggia, who sought to return the painting to its country of origin. The incident caused an international scandal. Two years later *La Gioconda* was located and brought back to France, where it was reinstalled under high surveillance at the Louvre. This episode served only to fuel more interest in the compellingly enigmatic portrait itself. *Mona Lisa* remains the world's best-known, most discussed, and most frequently reproduced work of art.

Mona Lisa's fascinating smile is ineffable. The sitter's thoughts and life story are a source of endless speculation. Mona Lisa is most likely the wife of Francesco del Giocondo, a city official. It has been suggested that she is depicted in mourning, perhaps for her own daughter, which would explain the light black veil covering her hair. Posing before an imaginary landscape whose rivers fade into a distance of blue fog, *Mona Lisa* is an image of perfection rendered all the more arresting by the stunning presence of her gaze.

Leonardo da Vinci, *Mona Lisa*
(La Gioconda), c. 1503–06. Oil on wood,
30¼ × 21 ins (77 × 53 cm).

■ Muséum Central des Arts

The Central Museum of Arts, which was to become the Louvre, originated in a decree of the National Convention of July 27, 1793. It took more than a century for the palace, abandoned by Louis XIV for Versailles in 1678, to be converted into a museum. Around four hundred paintings from the royal collection were in deposit at the Louvre at this time. While in a state of general disarray, they can be considered as prefiguring the future vocation of the palace. From 1669 on, the Salon Carré* was used for annual exhibitions

Hubert Robert and Vincent Pajou, and expansion work began on the Grande Galerie and the Salon Carré. The museum continued to grow. Masterpieces were confiscated throughout Europe in military campaigns, necessitating new viewing space in the Grande Galerie and, beginning in 1799, for the collection of antiquities in the Petite Galerie as well. In 1802 Vivant Denon was named Director of the Museum, which became the Napoleon Museum in 1803. A writer, diplomat, and collector, Denon assem-

by the Academy of Painting and Sculpture, attracting art lovers and spectators. In 1765 Diderot formulated his idea for opening a museum in the Grande Galerie* in the pages of the *Encyclopedia.* The Count d'Angivillier, the Director of Buildings, undertook decisive steps in this direction in 1774, but the project was interrupted by the French Revolution. It was necessary to inventory, restore, and expand the Royal Collection with new acquisitions. The first panel included

bled masterpieces from all periods. Upon the fall of Napoleon in 1815, however, a substantial portion of this treasure was returned to the land of its origins. To this day, the Louvre's collections continue to grow in the areas of antiquities, painting, drawing, and sculpture.

French School, *View of the Louvre's Antiquity Collection; Salle des Empereurs,* early nineteenth century. Watercolor, graphite and ink, 8 x 15⅔ ins (21.5 × 39.8 cm).

■ Napoleon III's Apartments

Proclaimed Emperor of France on December 2, 1852, Napoleon III charged the architect Ludovico Visconti with the design of reception rooms for the new Secretary of State, as well as the construction of the Nouveau Louvre wing, intended to join the Louvre and the Tuileries palaces. Upon Visconti's death in 1854 Hector Lefuel took over the projects. The new suite of rooms was inaugurated on February 11, 1861, with a fabulous masked ball. From 1871 to 1989 these salons were occupied by the Ministry of Economy and Finance, but their décor and original furnishings are still marvellously intact. They were opened to the public in 1993, and constitute a uniquely complete and exceptional example of the Napoleon III style.

Visitors enter the large antechamber with its carved wooden wall panels from the "Minister's stairway." The Introduction Gallery opens into the Family Room, which leads to the smaller quarters, as well as to the Theater Salon, decorated in floral and musical motifs and embellished with Auguste Gendron's painted ceiling depicting *The Seasons of Flowers*. Next is the Grand Salon, with its imposing furniture, magnificent crystal chandelier, sumptuous fabrics, its gold, marble and bronze bearing witness to the era's penchant for luxury and comfort. Paintings above the windows depict the construction of the Louvre and the Tuileries, while the ceiling illustrates the joining of the two palaces by Napoleon III. The Grand Salon leads into the Small and Large Dining Rooms, which open in turn into a large Reception Room. The decoration here is more muted. A ceiling painted with exotic birds embellishes the Large Dining Room, whose monumental air is exemplified by the long table and gilt bronze sideboard. Back stairs lead down to the silverware collection.

Neoclassicism

In the mid-eighteenth century, European art was overtaken by a renewed passion for Greek and Roman antiquity and a genuine interest in the study of classical art of the Renaissance. Artists began turning away from frivolity and facile erotic and libertine scenes, as well as from the rococo and baroque legacies in painting. At the same time, the French Revolution of 1789 brought expectations throughout society for profound change and a renewal of moral values. Neoclassical painting was already closely linked to these currents when the excavation of Herculaneum and Pompeii revived a taste for antiquity. Artists from throughout Europe flocked to Rome to study the works of antiquity, as well as sixteenth- and seventeenth-century paintings, forming a new perspective on the classical conception of beauty. The Eternal City became the nucleus of what came to be termed "neoclassicism." Painters made reference to Greek and Roman literature, whose many legends exalt the values of heroism, duty, and self-sacrifice. The new style emphasized clarity, economy, and emotional force of expression.

The painter David,* after spending five years in Rome where he completed his masterpiece *The Oath of the Horatii,* was recognized as the foremost practitioner of neoclassicism, and the *Oath* is unanimously viewed as the movement's manifesto. The story, taken from Roman antiquity, extols courage and patriotism, virtues that the modern hero, engaged in the fervent idealism of the French Revolution, also prized.

Parthenon Frieze

The frieze, over 525 feet (169 meters) in length, was situated high on the wall beneath the peristyle gallery of the Parthenon in Athens. It illustrates the long procession that took place once

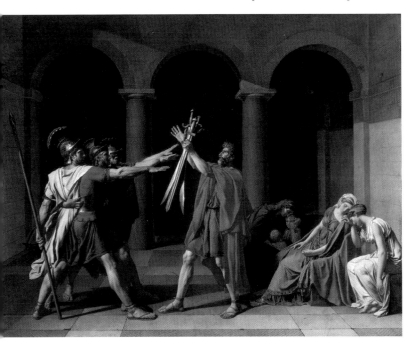

every four years for the great Panathenaic festival, when the entire population of Athens joined together in a celebration of the goddess Athena. On this occasion the *ergastines,* or Athenian girls, who wove and embroidered the *peplos,* the goddess' sacred garment, came to offer their handiwork to the deity.

This fragment from the east side depicts the procession's arrival near the gods' gathering place. The *ergastines* are accompanied by two attendants who regulate their steps. They advance with a slow solemnity barely illustrated by the light movements of their left legs. The background was originally blue. Numerous sculptors, under the direction of Phidias, carved the frieze on marble from the Pentelic quarries. The sensitive precision of their work, apparent in the handling of the drapery, marks the apogee of classical Greek Sculpture.

■ Pietà

The Virgin's words from Jeremiah's Lamentations are inscribed in Latin along the upper edges of this large painting: "Oh you who go by this path, look and see whether there

Plaque from the Parthenon Frieze, c. 440 B.C. Marble, 3 ft 1¼ ins × 6 ft 9½ ins (0.96 × 2.07 m).

Enguerrand Quarton, *Pietà of Villeneuve-lès-Avignon,* c. 1455. Oil on wood, 5 ft 4 ins × 7 ft 2 ins (1.63 × 2.18 m).

is another pain like mine." In this depiction of the Pietà, the Virgin holds her dead son in her lap, the focus is clearly on her anguished visage.

In keeping with tradition, the donor of the work is depicted in prayer before the scene, appearing here on the same scale as the sacred figures. The donor is believed to be Jean de Montagnac upon his return from the Holy Land, evoked by a view of Jerusalem to the left. The Virgin, Mary Magdalene, and St. John, who removes the crown of thorns, stand out boldly against the gold background. The body of Christ, stiffened with death, seems almost to break in the middle. A sense of monumentality is conveyed by the volumes that appear to be incised into the painting, and the direct, austere lighting.

The painter Enguerrand Quarton was born in Laon, to the north of Paris. He was active from an early age in Provence, where he remained from 1444 to 1466. During this period, he signed seven contracts for large altarpieces. The date of his death is unknown. Quarton's sense of monumentality, allied to Flemish realism, indicate his training in northern France, possibly in contact with van Eyck and van der Weyden. He is the most illustrious representative of the fifteenth-century Avignon School.

■ Portrait of an Old Man

This painting illustrates the affection of a young boy in the arms of an old man, presumably his grandfather. Afflicted with a deforming *rhinophyma,* which Ghirlandaio (1449–1494) renders with precision, the old man tenderly gazes upon the child's candid beauty. The space, which opens onto an imaginary landscape, is imbued with the silent communion of youth with age.

The old man is possibly Francesco Sassetti (1420–1490), director of the Medici Bank whose name is associated with the decoration of the funerary chapel of Santa Trinita in Florence. He was part of the class of bankers, merchants, and bourgeoisie which made Florence one of Europe's most prosperous cities the fifteenth century.

This work was acquired by the Louvre in 1880. It bore mysterious scratches on the forehead, left eye, and nose of the old man. The painting was restored

Domenico Ghirlandaio, *Portrait of an Old Man and a Boy,* c. 1490. Oil on wood, 26½ × 19 ins (67 × 46.3 cm).

in 1995, and the markings were blended into the skin so as not to detract from the overall effect.

Poussin (Nicolas)

Poussin (1594–1665) is considered the most representative painter of French seventeenth-century classicism.* His work is at times complex, consistently erudite, and the Louvre's thirty-eight Poussin canvases, a third of the artist's production, enable viewers to follow the successive stages of his development.

After leaving his native Normandy, Poussin worked in Paris, not attaining his dream of going to Rome until 1624. It is there that the lion's share of his activity took place, with only two years of interruption when Louis XIII called him back to the French court.

In Rome, Poussin immediately found patronage from cultivated and erudite collectors. He had many faithful clients, including Cassiano dal Pozzo for whom Poussin painted a series of the *Seven Sacraments*. Such clients' interest in the study of antiquity encouraged the artist to devote himself increasingly to easel paintings with noble or dramatic subjects from Greek and Roman history and mythology. His balanced compositions became increasingly static. Poussin's most personal work won him international fame. Simple allegories like *The Poet's Inspiration* (1630) solidified his reputation as the "philosopher painter," while other canvases, for example the *Arcadian Shepherds* (1638–40) express the frailty of human happiness. Between 1644 and 1648 Poussin painted a second series of the *Seven Sacraments* for the Parisian collector Chantelou, whose monumental compositions and majestic figures articulate the artist's pictorial and intellectual ideal.

During the last twenty years of his life, Poussin developed a new interest in landscape. His *Diogenes* depicts the bounty of nature assuring human happiness. In *The Seasons*, Poussin creates a synthesis between natural beauty and Biblical narrative, with each season symbolizing a different stage of human destiny.

Nicolas Poussin,
Autumn,
1660–64.
Oil on canvas,
3 ft 10½ ins ×
5 ft 3 ins
(1.18 × 1.60 m).

Antonio Canova, *Cupid Awakening Psyche* (detail), 1793. Marble, 5 ft 6 ins × 5 ft 1 in (1.68 × 1.55 m).

The Pyramid of the Louvre. I. M. Pei, architect, 1989.

■ Psyche

Upon inhaling from a magic vial, Pysche plunged into mortal sleep, to be awakened by Cupid's kiss. A soft breath of life transports the young goddess into the arms of her lover. Antonio Canova (1757–1822) plays with the perfect balance of the pyramidal composition to translate this exquisite moment by evoking the grace, beauty and affection that unites these young gods. The purity of the white marble and the perfection of Canova's technique give this sculpture a refined elegance as well as a sweet and subtle sensuality. First destined for an English collector, Joachim Murat pur-

chased the piece for his chateau de Cillers, in Neuilly. A second version was also completed, which is in the Hermitage Museum, in Saint Petersburg. Canova was a sculptor and a painter. His initial training was in Venice. He then went to Rome where he was an impassioned student of works from antiquity, and he associated with the *école du nu* of the French Academy. He was in close contact with the international milieu that made its way to Rome at the time, and he became quite successful. He took inspiration from several ancient sources for his *Theseus Defeating the Minotaur*, the success of which led to several important commissions. From funerary steles to allegorical monuments, he was adept at creating works with mythological themes, such as the Louvre's *Psyche*, and his contemporaries esteemed his work. As the acknowledged master of neoclassicism* in sculpture, he was invited to Paris by Emperor Napoleon I. Canova created the colossal *Emperor Holding Victory* for Napoleon I and numerous other works for members of his entourage. He was one of the last artists to affirm the primacy of Italian art in Europe.

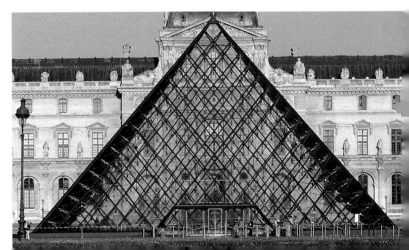

■ Pyramid

In 1981 a decision was taken by the then President François Mitterrand to expand the Louvre, to provide public entry areas and services, and to move collections into the north wing still occupied by the Ministry of Finance.

Architectural work was contracted with the American architect of Chinese origin Ieoh Ming Pei. In the center of the Cour Napoléon, Pei conceived an immense glass pyramid to house the vast entry hall, which would provide access to the museum's different wings, as well as to the auditorium, the book store, rooms destined for educational activities, and the commercial center of the Carrousel (itself illuminated by an inverted glass pyramid).

Its creator described it as "transparent and reflecting the sky," and as well as being visually stunning, the Pyramid is an achievement of technical genius. Rising between the highly decorative façades of the Cour Napoléon, the Pyramid is flanked by three smaller pyramids, also of glass. The main pyramid measures 72 feet (22 meters) in height and 114 feet (35 meters) in length. To keep light streaming into the vestibule, the Pyramid is comprised of nearly eight hundred glass lozenges and triangles assembled on an aluminum structure. It is supported by ninety-five tons of steel girders and joints. The transparent, non-reflecting glass, engineered for lightweight durability, was manufactured by French company Saint-Gobain. The Pyramid is cleaned each week by a specially designed robot.

■ Pyxis of Al-Mughira

The Umayyad dynasty in Spain produced elaborate works of art representing court life. Ivory art was then at its apogee. This pyxis, or circular box, is named for Al-Mughira, the son of Caliph Abd al-Rahman III. It is a masterpiece of the genre, whose great richness of detail in powerful relief work reaches a centimeter in depth. The scenes on four multi-lobed medallions represent three figures on a pedestal, a lion attacking a bull, the gathering of dates, and the gathering of falcon eggs. The meaning of the last two medallions remains a mystery. Perhaps they are allusions to the taking of power, since the Umayyad dynasty was experiencing a serious problem concerning its line of succession. The box was probably made in celebration of the coming of age or the political maturity of the young prince who was eighteen at the time. But when Al-Mughira was about to assume the caliphate upon his father's death some eight years later, he was assassinated and the throne passed to a young child. This coup d'etat overturned the dynasty and led to the pillaging of the palace and the dispersion of many of its objects. Almost all made their way to the Christian north of the Iberian peninsula. There they became parts of church treasuries, where they came to assume other functions. Ivory containers of this sort used for the sacred host became known as pyxes.

Medinat al Zahra Royal Workshop, *Pyxis of Al-Mughira,* Spain, 968 A.D. Sculpted ivory, 6 × 3¼ ins (15 × 8 cm).

■ RAFT OF THE MEDUSA

On July 2, 1816, a frigate sank off the coast of Africa. It had been sent by the government of Louis XVIII to take possession of Senegal which had recently been restored to France by treaty. The captain abandoned 146 passengers and crew members on a life raft. For thirteen days, the raft drifted under a blazing sun while the victims died of exposure and practised cannibal-ism to keep from starving. In 1817, two of the fifteen survivors published an account of this event which captured public imagination. Théodore Géricault (1791-1824) took this tragedy as the subject of an ambitious work that required more than a year to complete. He researched every detail of the incident, studied cadavers in the morgue of the Beaujon Hospital, and made startlingly realistic sketches. His work depicts the raft on rough waters, its sail full of wind. The painting's heavy impasto and the green tonality of the bodies evoke an apocalyptic atmosphere of suffering and fear of

death. The victim at the summit of the pyramid formed by bodies waves some red tatters; this is the only sign of hope for those who are still alive. The Argus, the ship that will save the last survivors, appears on the far horizon.

From childhood, Géricault was fascinated by horses. They are the subjects of his earliest works illustrating episodes from the Napoleonic Wars. His *Charging Cavalry Officer of the Imperial Guard* attracted the attention of his contemporaries with its monumental format and vigorous use of color. In Rome from 1816 to 1817, Géricault was impressed by the work of Michelangelo. Upon returning to Paris, he became interested in depicting current events, as evidenced by his involvement with the Medusa shipwreck. In England (1820–21) the artist used lithography to depict scenes from daily life, horse races and boxers. His last works were portraits of the mentally ill commissioned by the psychiatrist Étienne-Jean Georget. They are stunning images of insanity and dementia. Improperly cared for following a riding accident, Géricault died at the age of thirty-three, after prolonged suffering.

Both realistic and tragic, Géricault set the stage for Romantic* painting.

Théodore Géricault,
The Raft of the Medusa,
1819. Oil on canvas,
13 ft 9 ins × 23 ft 6 ins
(4.19 × 7.16 m).

◼ Raherka and Merseankh

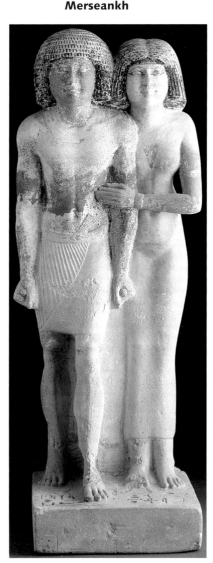

Raherka and Merseankh, c. 2500–1350 B.C. Painted limestone. 20¾ ins (52.8 cm).

Inspector of the Jackal Scribes in the vizier's service, Raherka is accompanied by his wife Merseankh who places a loving hand on his shoulder and follows him, holding his arm. Identical in height, the couple are dressed in the Old Kingdom style. The husband wears a side-pleated loincloth; the wife a long, close-fitting dress. In accordance with artistic conventions, the man's body is red and the woman's white. Statues of joined couples were common in this period of Egyptian sculpture, symbolizing the importance of family ties. The work's impression of harmony, confidence, and intimacy guarantee the models' happiness and stability, as well as the promise of numerous offspring.

◼ Raphael (Raffaello Sanzo)

The details of Raphael's (1483–1520) early training in Urbino remain unclear, although it is known that he studied for a time in Perugino's workshop before going to Florence, where he resided from 1504 to 1508. Close study of the work of Leonardo da Vinci played a decisive role in Raphael's development, and the *Madonnas* and *Holy Families* painted during his Florentine period evidence the artist's precocious maturity and classical style. In *The Virgin and Child with St. John the Baptist,* also referred to as *"La Belle Jardinière,"* Raphael creates a pleasant bucolic familial scene, compositionally joining the Virgin and children in a subtle play of gazes and gestures.

In 1508 Raphael was summoned to Rome by Pope Julius II to decorate the Vatican Stanze (rooms). In the Signature Stanza (1508–11) the artist brings together poets and philosophers from throughout the ages, alternating in harmonious yet monumental compositions with episodes of violent tension and drama. Raphael was prolific, heading a prosperous workshop full of hard-working,

efficient students. As a portraitist to eminent personages, he employed his inspiration and perfect technique to convey his sitters' noble power, infinite beauty, or elegant intelligence, as in the case of Baldassare Castiglione, the accomplished gentleman, writer, and diplomat. Raphael decorated the banker Agostino Chigi's Villa Farnesina with a magnificent *Triumph of Galatea* in which the goddess drives her conch draw by two dolphins. Throughout his career, Raphael painted portraits, devotional works and large altarpieces, whose increasingly intense expression and dense coloration culminate in the brilliant *Transfiguration,* completed at the time of his death.

Raphael, *The Virgin and Child with St. John the Baptist,* known as *La Belle Jardinière,* 1507. Oil on wood, 4 ft × 31½ ins (1.22 × 0.80 m).

Scepter of
Charles V,
1365–80.
Gold, pearls
and precious
stones, 23½ ins
(60 cm).

■ Regalia

Until the revolution, the Regalia, or insignia of royal authority used at coronations, were kept in the royal abbey of Saint Denis, as part of the Saint Denis treasury. The abbot of Saint Denis was responsible for conveying the items to Reims Cathedral for the coronation of French kings. On these solemn occasions, the future king would be escorted to the cathedral where he took his oaths and received the "marks of chivalry." The archbishop gave him holy unction, the king was adorned with the fleur-de-lis robe and was bestowed with the insignia of coronation. Finally, the archbishop placed the royal crown upon his head.

The Regalia include the *Éperons*, or royal spurs, the sword known as *Joyeuse,* said to have been Charlemagne's, and the *Scepter of Charles V.* Charles V had this golden and formerly enameled scepter prepared for the coronation of his son, Charles VI. The three scenes depicted on the knob beneath the small statue of Charlemagne represent the most important events in Charlemagne's life. These iconographic choices are evidence of the importance that the Valois kings gave to the cult of Charlemagne, as well as the determination with which the early Valois kings sought to evince their attachment to the Carolingian line. The

majesty and authority that emanate from the Charlemagne statuette contrast with the elegant delicacy of the pearl and precious-stone decorated knob.

■ Rembrandt (Rembrandt Harmensz Van Rjin)

Born in the Dutch city of Leiden, Rembrandt (1606–1669) studied with Pieter Lastman in Amsterdam before returning to his native city. He distinguished himself early on, winning enthusiasts and acclaim for his treatment of chiaroscuro, his uncanny expression of emotion, and his technical virtuosity and pictorial richness. Rembrandt worked in every genre: portraiture, landscape, religious and mythological scenes, and history painting. His series of self-portraits spans his entire career in an intimate and fascinating dialogue with aging and death. Rembrandt settled in Amsterdam in 1631. His group portraits, such as *Dr. Tulp's Anatomy Lesson* (1632), along with his large-scale renderings of wealthy bourgeois figures, soon established him as the city's most sought-after artist. As Rembrandt entered into a brilliant phase of his production, his paintings took on the luster of precious materials presented with outstanding virtuosity. *The Night Watch* (1643) marks the culmination

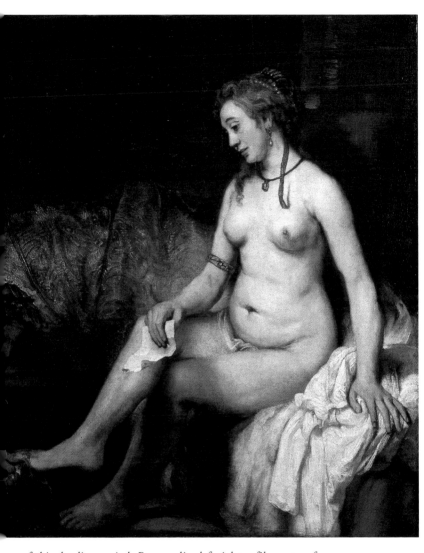

of this dazzling period. Rembrandt's great masterpieces date from the 1650s. He displays his full genius and ambition in history painting with compositions based on Biblical episodes. In *Bathsheba,* the artist presents a life-size likeness of his model and mistress Henrickje Stoffels. This magnificent nude rendered in warm, coppery tones is seated before a rich brocade bedspread. The full forms, idealized facial profile, note of coral in the hair, and stunning whites constitute a moving hymn to beauty.

Suffering from financial and personal problems at the end of his life, Rembrandt continued to paint. His approach even became increasingly audacious and ever freer, imposing his creative power and profound originality up until the end of his career.

Rembrandt, *Bathsheba,* 1654. Oil on canvas, 4 ft 8 ins × 4 ft 8 ins (1.42 × 1.42 m).

Hubert Robert,
*The Pont du
Gard,* 1787.
Oil on canvas,
7 ft 11¼ ins ×
7 ft 11¼ ins
(2.42 × 2.42 m).

▮ Robert (Hubert)

From 1754 to 1765 Hubert Robert (1733–1808) was in residence at the French Academy in Rome, touring Italy with his friends Fragonard* and the Abbot of Saint-Non. A fascination with ancient Rome inspired his drawings and paintings of Roman monuments. His imaginary views, mixing genre scenes, vegetation, and architectural fragments, won him the nickname "Robert of the ruins."

In 1778 Robert was named Garden Designer to Louis XIV, who commissioned the artist to redesign the gardens at the Versailles and Rambouillet Castles, as well as the Apollo Baths at Versailles.

Robert painted views of Paris for thirty years. In 1787 he received a command for four decorative panels illustrating the Roman monuments of Provence for the royal apartments of Fontainebleau Castle. Grouped under the title of *Principal Monuments of France,* this suite of paintings forms a unique ensemble. The majestic ruins of the Pont du Gard, the Masion Carrée, the Temple of Diana at Nimes, and the Triumphal Arch in Orange are brought to life with picturesque figures and infused with poetic light.

In 1784 Robert was named Keeper of the King's Paintings and executed a series of imaginary views of the

Grande Galerie.* He was imprisoned in 1793, released in 1794, and named a committee member of the newly created Museum,* which was to become the Louvre Museum.

■ Romanticism

"I don't like reasonable painting: my messy spirit needs to shake up, undo, try a hundred possibilities before arriving at the goal that pushes me on." With this declaration, Delacroix* affirmed his affinity with Romanticism, contesting the neoclassical order and vaunting the sense of freedom that gripped

him with the impulse to invent a new language. For the Romantic painter, art is above all a question of expressing one's sentiments in an original way, feeling and conveying one's emotions, creating a universe that foregrounds the imaginary, the fantastic, a taste for melancholy and for the picturesque. Often uninterested in the traditional tour of Italy, the Romantic artist would find inspiration in nature, whether violent, dreamy, or meditative. Steeped in contemporary literature and dramatic writers such as Chateaubriand, Byron, Goethe, or Ossian, the Romantic artist also sought to bear witness to current history such as the Napoleonic Wars, civil strife, or the shipwrecked survivors on the raft of the Medusa.* The East, with its exoticism, colors, and light also inspired Romantic painters' palettes.

Antoine Jean Gros, *Napoleon Bonaparte Visiting the Victims of the Plague at Jaffa*, 1804.

Oil on canvas, 17 ft 2 ins × 23 ft 5½ in (5.23 × 7.15 m).

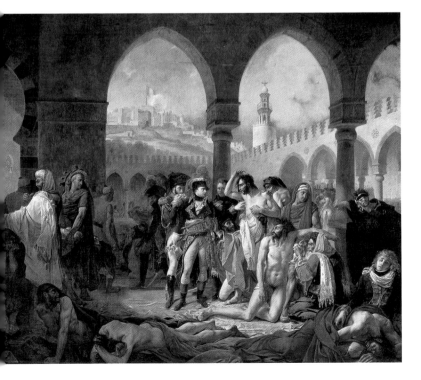

Salle des Caryatides

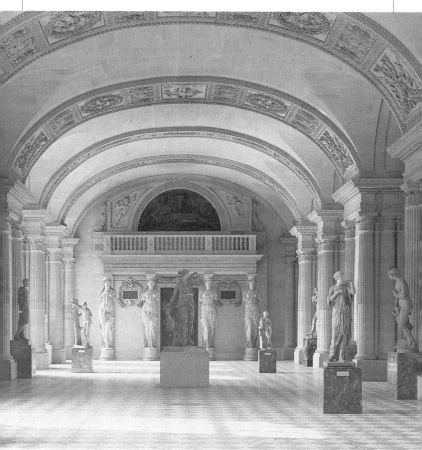

The Salle des Caryatides, view of
the Royal Tribune.

Built by Pierre Lescot on the ground
floor of the Sully wing, the Salle des
Caryatides (1546–49) is one of the
Louvre's most lovely rooms. Jean
Goujon's four imposing female
caryatids which support the musi-
cians' gallery were added in 1550.
The opposite southern section
served as the Royal Tribune. The
wax death mask of Henri IV was
exposed here in 1610, but the Salle
also served as a theater where
Molière's *Le Docteur Amoureux*
played for the first time before
Louis XIV on October 24, 1658.
From 1692 to 1793 the Salle des
Caryatides, then called the Salle des
Antiques, housed the royal collec-
tion of Antique, Medieval, and
Renaissance marble pieces. It became
the headquarters of the French Insti-
tute, founded in 1795, and was
incorporated into the Napoleon
Museum in 1806. Decoration was
completed by Charles Percier and
Pierre Fontaine, with a vast marble
chimney designed around Jean
Goujon's figures.

■ Salons

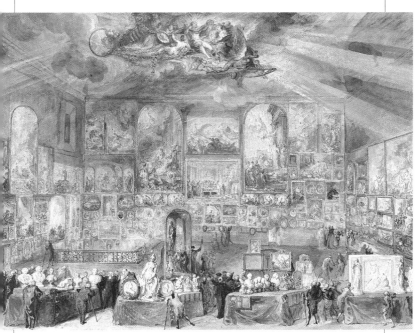

The exhibition of work by members of the Royal Academy of Painting and Sculpture, inaugurated in 1663, was organized for the first time in 1667. After starting off in the Palais Royal gallery, and then taking place in the courtyard of the Richelieu residence, these exhibits moved to the Louvre in 1669. The 1704 Salon was held in the Grande Galerie, and from 1725 on it was held in the vast salon called the Salon Carré (despite its rectangular shape; *carré* means "square") which had been configured following a 1661 fire to adjoin the Apollo Gallery. The term *Salon* was adopted to refer to these regular Louvre exhibitions.

Up until 1791 the Academy exhibitions were inaugurated with great ceremony on August 25, the day of St. Louis and the festival of the king. The exhibits were often accompanied by a printed program: the first exhibition catalogues. The Salons

Gabriel Saint-Aubin, *The Salon of 1767 at the Louvre,* eighteenth century (Detail,private collection.) Watercolor.

varied between being annual and biannual events. They attracted a growing number of viewers who were allowed admission to the royal collections only on the days of the show. The number of works on display increased steadily as well, from 220 in 1763 to over 800 in 1791. Academy members were permitted to send as many works as they chose. The King's Director of Buildings ordered the exhibitions. An artist, chosen by his colleagues, was elected "Decorator" or "Hanger," responsible for the works' hanging and arrangement. The Academy expositions continued to take place in the Salon Carré through 1793. After the dismantling of the Academy, the Louvre continued to house the Salon of Living Artists in this hall until 1848.

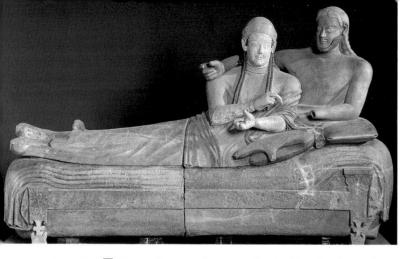

■ Sarcophagus of a Married Couple

This sarcophagus was found in a tomb in Carveteria, in Etruria on the Italian peninsula. The monument, made for a prominent Etruscan family and designed to hold the mortal remains of the dead, is sculpted in the shape of a divan on which the couple reclines in the traditional banqueting position. The positioning of the woman in front of the man corresponds to her prominent role in Etruscan society. Her graceful gesture probably represents the anointing of her husband's left hand with a few drops of perfume. Wine was kept in the flat objects serving also as cushions. Influenced by Ionian Greek art, the sculptor sought to convey the harmonious love of the couple united in death, their kind facial expressions emphasised in color pigment. The bodies are treated in archaic style, with the stiff, barely delineated legs typical of Etruscan conventions. This masterpiece, acquired in 1861, was part of the Campana Collection.

■ Scribe

This statue was discovered in the excavations headed by the

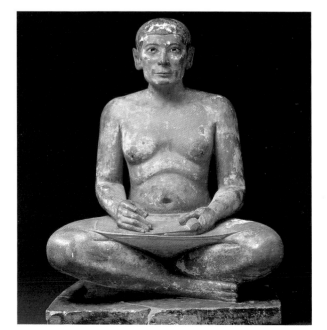

Egyptologist Auguste Mariette at Saqqara in the mid-nineteenth century. The scribe played an important role in ancient Egyptian government. He possessed the skills of reading, writing, and drawing, and often enjoyed a privileged, powerful status. While the Egyptians did not invent writing, by 3000 B.C. they had perfected a system of hieroglyphs whose precise grammar and rules are known today due to the deciphering and decrypting work of Jean-François Champollion in the early nineteenth century.

This sculpture is exceptional for its volumetric equilibrium, fine modeling, sensitive treatment of the hands, and well-preserved vivid color. The round belly suggests the sitter's prosperity. The gaze is lively and twinkling. The eyes with their rock crystal irises animate the attentive and intelligent face. The Egyptian patron god of scribes is Thot, "master of the divine word," represented by an ibis or a monkey.

◼ Seti I and the Goddess Hathor

Brought to France by Jean-François Champollion in 1829, this bas-relief comes from the tomb of Seti I in the Valley of the Kings, where it was found at the half-way point of a long corridor cut into the mountain leading to the sarcophagus. The goddess Hathor, with a headdress of horns and the solar disk, greets the king who is leaving the world of the living. She takes the king's hand and offers him the *menat* necklace, a symbol of rebirth. Hathor is the goddess of the Theban necropolis. In this rare meeting, the goddess and the king seem

drawn to each other. Within the rectangular frame, the balanced composition is accentuated by the figures' grace and elegance, the transparent royal garments, and the fine facial modeling. The color, which has undergone numerous restorations, underlines the sumptuous attire and decorative detail.

Seti I and the Goddess Hathor, c. 1294–79 B.C. Painted limestone, 7 ft 5 ins × 3 ft 5¼ ins (2.26 × 1.05 m).

97

■ Slaves

In 1505, Pope Julius II summoned Michelangelo (1475–1564) and commissioned him to build a colossal funerary monument. It was to be located at St. Peter's in Rome, and was to attest to the eternal glory of the Pope and his Church Triumphant. The most magnificent blocks of marble were selected from the Carrera quarries to be used by the sculptor who had conceived a free-standing multi-storey mausoleum, possibly inspired by the tombs of antiquity, and to be decorated with niches and stone statues (including Moses leading the Jews out of slavery in Egypt, and figures of slaves whose allegorical significance is still a matter of debate). The project was abandoned, then resumed in 1513, transformed, reduced, and finished only in 1545. In the end, Pope Julius was accorded a final resting place at San Pietro in Vincolo rather than at the Vatican. Among the statues from the original plan, only *Moses* was completed, and two of the *Slaves* remained unfinished. They came to the Louvre during the French Revolution, having passed through the Montmorency and Richelieu collections.

A portion of the slaves' bodies remains embedded in the marble blocks from which they are sculpted. The "dying slave" appears resigned to the prospect of his soul passing from the physical world, as he calmly leaves behind the

Michelangelo,
Dying Slave,
1513–15.
Unfinished,
marble,
7 ft 5¾ ins
(2.28 m).

mortal beauty of his body. The "rebellious slave" seems to want to tear himself free from the bonds that cruelly hold him prisoner. But what was the artist's true intention? Are these allegorical figures representing provinces subjugated by the Pope? Do they perhaps symbolize the liberal arts which the death of the patron Pope leaves enchained? Could they depict the human soul incarcerated in the body?

Michelangelo,
Rebellious Slave,
1513–15.
Unfinished,
marble,
6 ft 10¼ ins
(2.09 m).

■ STAIRCASES

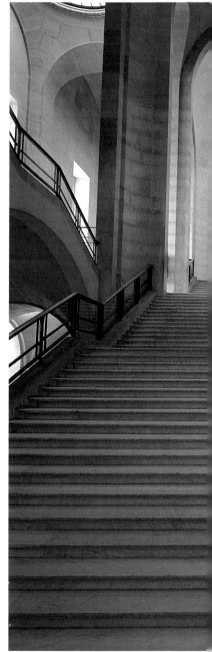

Whether in marble or designed with the latest techniques, the Louvre's staircases allow for passage from one floor to another, but their volumes, forms, and monumental proportions earn them the status of artworks in their own right.

The Henri II Staircase (Sully) was built by Pierre Lescot in 1553, and embellished with sculptures by Jean Goujon. It leads from the Salle des Caryatides* on the ground floor to the Salle des Gardes on the next level, and is covered by a coffered arch. Henri II's initials, his emblem, the crescent moon, and an evocation of the goddess Diana complete the decoration.

The Daru Staircase (Denon) was constructed in 1855 by Hector Lefuel as part of Napoleon III's Nouveau Louvre plan, and bears the name of the Superintendent of the Emperor's Lodgings, Count Daru. In 1883 the *Winged Victory of Samothrace,** discovered on the island of Samothrace, was installed to dramatic effect at the summit of the staircase, in keeping with the staircase's theatrical conception. The Mollien Staircase (Denon) rises from the center of the Mollien Pavilion in counterbalance to the Daru Staircase. François Nicolas Mollien was a State Councilor and Minister to Napoleon I. The elegantly unfolding steps, adorned with a ramp of geometric arches, leads from the Italian sculpture rooms on the ground floor to the painting collections on the next level. The ceiling painting by Charles-Louis Muller represents *Glory Crowning the Arts* (1868-70).

The North (Assyrian) Staircase and the Midi (Egyptian) Staircase are at opposite sides of the Colonnade* (Sully). They were built in 1810 by Pierre Fontaine to provide access to the Royal Apartments. Today, gods from antiquity and allegorical sculptures which decorated the bas-reliefs along the first floor railing are located in the Department of Egyptian Antiquities.

The Lefuel and Colbert "Ministre" Staircases (Richelieu) were designed by Lefuel to service the offices, library, and apartments of

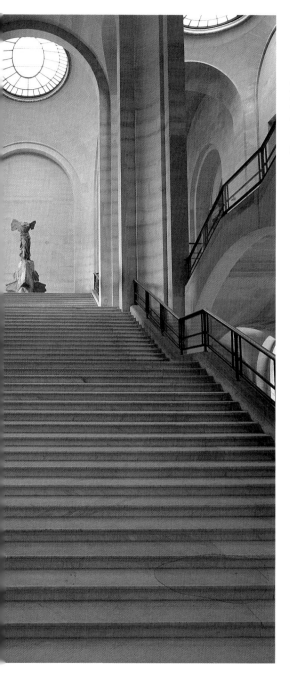

Hector Lefuel, the Daru Staircase, 1855 (*Winged Victory of Samothrace* on the landing).

the north wing of Napoleon III's Nouveau Louvre. The Lefuel Staircase is a majestic double flight of stairs, and the Colbert Staircase opens out onto an elegant portico of double columns.

Ieoh Ming Pei's modern staircases complete the list. A large escalator leads to the floors of the north wing. A spectacular helix staircase, with an elevator at its center, punctuates the immense reception hall of the Pyramid.

■ Suger's Eagle

Suger was the abbot of Saint-Denis from 1122 until his death in 1151. He was a friend and advisor first to Louis VI, then to Louis VII, from whom he took charge of the kingdom in the king's absence during the Second Crusade of 1147–49. With his political power, Suger sought to develop and consolidate royal authority, and the Abbey of Saint-Denis was a nucleus for his ambitions. He undertook brisk reconstruction of the Abbey where the new choir, built between 1140 and 1143, is one of the earliest examples of Gothic architecture, with its radiating chapels, rib vaults and the light through

Suger's Eagle, Saint-Denis, before 1147. Porphyry vase, gilt silver and niello, 17 × 10½ ins (43.1 × 27 cm).

its stained glass windows. Suger was also dedicated to building up his Abbey's precious holdings, and he ordered inventive works from goldsmiths in the Ile-de-France region. These pieces include four adorned mountings for antique hard stone vases which were executed before the middle of the twelfth century and which remained at the Abbey until 1793. These are *Suger's Eagle,* the *Aliénor Vase,* and the *Sardonyx Ewer,* all in the Louvre collection, and *Suger's Chalice* at the National Gallery in Washington, DC.

The most spectacular of the vases, *Suger's Eagle,* is the result of contemporary work commissioned by Suger that is assembled onto an even older piece. That piece is an Egyptian or Imperial Roman porphyry vase he claimed to have found in a trunk at the Abbey. A Latin inscription at the base of the neck explains: "This piece deserved a setting of gold and precious stones. It was made of marble but is now more precious than marble." Transformed into an ewer, this majestic eagle stands firmly upon its talons. Its proud head is supported on a long neck with perfect plumage. Wings spread on either side of the vase, emphasizing the power and authority behind the work.

■ Tamutneferet's Coffins

A large portion of religious practices in ancient Egypt were focused on the afterlife and sustained by a belief in human immortality. Upon death, corpses were handled according to precise funerary rites which were meant to insure survival after death. Afterlife began in

the tomb, where the mummified corpse was placed in a sarcophagus and surrounded by numerous objects whose nature and quantity varied over the centuries. It was during the New Kingdom that sarcophagi took on a more human-like form. The material of the sarcophagi, as well as their number, varied according to social rank and wealth.

The multiple coffins of Lady Tamutneferet, singer of Amon, are in stuccoed and painted

Titian (Tiziano Vecellio)

A student of Giovanni Bellini and then of Giorgione, Titian (1488/1490–1576) was already famous at the time of his second master's death in 1510. From Giorgione, Titian acquired a strong feel for nature, a mastery of color, and his handling of form. Titian's passionate temperament and strong personality helped quickly establish him as the principal Venetian painter of the sixteenth century. He worked in

Tamutneferet's coffins, c. 1200–1100 B.C. Painted and gilt wood; largest sarcophagus, 6 ft 1 ins (1.80 m).

wood. The decoration presents a rich iconographic repertoire incorporating major gods of the Egyptian pantheon. Nut, the sky goddess, is often depicted on the inside of the coffin lid, directly above the corpse she will lead on to rebirth.

all manner of genres and themes, from religious and historical painting to portraiture.

Titian's renown was at its peak by 1520. Princes and monarchs were enthralled by the sumptuous classicism of his work. The painter brought a whole new

Titian, *Concert Champêtre*, c. 1509. Oil on canvas, 3 ft 5¼ ins × 4 ft 5½ ins (1.05 × 1.36 m).

Tomb of Philippe Pot, last quarter of the fifteenth century. Painted and gilt stone, 6 ft 11 ins × 8 ft 8¼ ins (1.80 × 2.65 m).

dramatic tension and creative force to the use of color. In 1530 Titian found a powerful patron in the Emperor Charles V, who commissioned endless portraits that demonstrate the artist's ability to express his most powerful contemporaries' grandeur and taste for ceremony.

Around 1540 Titian came under the influence of the mannerist tendencies of the time, as is evident in his *Crowning with Thorns* (1543). From 1550, working intensively in his studio, Titian produced a great number of religious works for church commissions and mythological scenes for royal courts. After the beautiful *Venus at the Mirror* painted for Phillip II of Spain, the artist depicted *Danaë,* then *Venus and Adonis,* of which he went on to paint numerous versions. The colors, applied rapidly in thick layers, play freely with light, generating increasingly intense and dramatic effects. In the *Martyrdom of Marsyas,* purple blood flows from the tortured body. Titian's *Pietà,* a complex, sweeping work of high drama, was left unfinished

when the artist died from the plague in 1576.

■ Tomb of Philippe Pot

Philippe Pot, Lord of La Rochepot and Seneschal of Burgundy, was named Chamberlain to King Louis XI. His great eloquence won him the nickname of "mouth of Cicero" among his contemporaries.

Before his death in 1493, Philippe Pot commissioned a tomb in Citeaux Abbey. On a slab borne by eight hooded mourners in black cloaks, Pot is represented as a knight lying with a dog at his feet. This nearly life-size monumental funeral procession takes the viewer by surprise. The bold and dramatic composition emphasizes the subject's power and grandeur, exalting his bloodline, his ancient lineage represented by the family arms. Devoid of all religious reference, this memorial is exceptional in its conception, although the theme of "criers," isolated in niches or joined in procession, is to be found in numerous monumental tombs of the late Middle Ages.

■ Tuileries

Before Catherine de' Medici commissioned Philibert Delorme to construct a residence on this site in 1564, tile manufacturers occupied the area close to the Louvre Palace, west of the fortifications of Charles V. The complex plan included several wings, but only one pavilion with two wings was to be completed by Delorme and his successor Jean Ballant. The queen called for an immense garden comprised of flower beds in the Italian style complemented by ponds, statues and pavilions. Bernard Palissy added a glazed terracotta grotto swarming with sleek ceramic snakes and lizards. Excavations of the Carrousel Courtyard have uncovered the remains of his on-site workshop.

On October 6, 1789, Louis XVI was conducted to the Tuileries by the revolutionaries, and the National Assembly convened in the garden's carrousel. In 1793 the theater, built in 1659, was transformed into an assembly hall for the Convention. As First Consul, Napoleon decided to reside in the Tuileries and commissioned the architects Percier and Fontaine to join the palace to the Louvre. As its entry, Napoleon ordered the Arc de Triomphe of the Carrousel to symbolize his numerous victories.

Work on the project was repeatedly interrupted, primarily for financial reasons. It was not until Napoleon III's Nouveau Louvre, drawn up by Visconti, that the two palaces were joined and inaugurated on August 14, 1857.

Israel Silvestre, *View of the Tuileries Palace from the Seine,* seventeenth century. Brown wash drawing.

On May 23, 1871, a fire started by the Communard rebels destroyed the Tuileries. Debate over whether to rebuild the palace lasted two years. In 1882, it was decided that the structure would be leveled, opening both sides of the Louvre onto the gardens, with a view of the Champs-Elysées.

VAN EYCK

Jan van Eyck,
*The Madonna
of Chancellor
Rolin,* c. 1435.
Oil on wood,
26 × 24¼ ins
(66 × 62 cm).

Van Eyck (Jan)

Van Eyck (c. 1390/1400–1441) was the greatest painter of the Northern Renaissance, and influenced all of Europe with his genius for conveying reality. He is renowned for having perfected oil painting technique.

In the service of John of Bavaria from 1422 to 1424, probably as a miniaturist, van Eyck was named chamberlain to Philip the Good, with whom he remained until his death. Van

Eyck settled in Bruges in 1429. In 1432 he completed the *Ghent Altarpiece* with his brother Hubert. This work, with its expansive figures, marks a significant new approach to the depiction of space and volume. A subtle portraitist, van Eyck represents his own likeness in the mirror of the interior scene, *The Arnolfini Couple.* For *The Madonna of Chancellor Rolin,* the painter plays with transparencies of light. The horizon

opens onto a garden which leads to an imaginary city. Details are handled with such minute precision that thirty varieties of flowers can be identified in the garden. The donor Nicolas Rolin is represented in prayer opposite the Virgin and Child, who blesses Rolin. The chancellor gave the painting to the collegiate church of Autun, from which it was seized during the French Revolution.

Venus de Milo,
c. 100 B.C.
Marble,
6 ft 7½ ins
(2.02 m).

■ Venus de Milo

Discovered in 1820 by a peasant on the Cycladic island of Melos, the *Venus de Milo* was given to Louis XVIII by the Marquis de Rivière. It became part of the Louvre collection the following year.

The statue has been identified as Aphrodite, the Greek goddess of beauty. Despite numerous searches, the arms were never found and their positioning remains a topic of debate. The body, whose weight is slightly shifted to the right, was sculpted in two pieces joined in the cascading fabric folds below the hips. The face's perfect beauty, with its delicate features and the lips' inscrutable expression, is reminiscent of the work of Praxiteles. But the soft sinuosity of the nearly-mobile body with its fairly realistic musculature allow the sculpture to be dated to the final phase of Greek art, the Hellenistic period.

Vermeer (Johannes)

Forty paintings, only a handful of which are signed and dated, suffice to establish Vermeer (1632–1675) as one of the greatest Dutch painters. Apart from two landscapes including the luminous *View of Delft*, Vermeer repeated the same subjects: uneventful interior scenes most often representing young women in dreamy or melancholy attitudes, reading a letter, writing, playing an instrument, or engrossed with some everyday task whose simplicity is rendered with impeccable tech-

nique. The lighting emphasizes the rigorous composition and reveals the beauty of the women's faces, the dazzle of their accessories, and the play of reflection and transparency in the textured folds of fabrics.

Bent over her embroidery, the young lace maker works in the silence of her room. This little masterpiece is stunningly simple. The subtle forms in the pyramidal composition are brought to life out of the regular background tones by the light which caresses the face, brings out the yellow tones of the dress and

Johannes
Vermeer, *The
Lacemaker*,
c. 1664.
Oil on canvas
on wood,
9½ × 8¼ ins
(24 × 21 cm).

magically accentuates the colored threads on the cushions.

Watteau (Jean-Antoine)

Watteau (1684–1721) came to Paris at the age of eighteen and worked first in the studio of Claude Gillot, known for his portrayals of the *Commedia dell'arte,* then as an assistant to Claude Audran, decorating Parisian homes. Under the patronage of the financier and collector Pierre Crozat, Watteau studied Crozat's Flemish and Italian drawings. In 1717 he was made a member of the Academy as a *fête galante* painter for his *Pilgrimage to the Isle of Cythera:* Watteau was the originator of this new genre which illustrates elegant, graceful figures engaged in outdoor parties of dancing, music, and amorous encounters against a sumptuously green natural backdrop. His numerous *fête galante* scenes include *Concert* and *The Pleasures of Love.* Watteau was fascinated by the theatrical milieu of *Pierrot (*also known as *Gilles),* melancholy in his costume of subtle white and pink tones. All around the actor are the characters of the Italian *Commedia dell'arte:* the doctor on his donkey, Colombine, the mezetin in his red costume, and a fourth actor in a hat with a feather-like notched brim. After a period in London, Watteau moved in 1720 to the home of his friend Gersaint, an art dealer on the Notre Dame Bridge, for whom the artist executed a masterpiece in the space of eight days, *Gersaint's Signboard,* his final homage to youth and the fragility of life.

Jean-Antoine Watteau, *Pierrot* or *Gilles,* c. 1718. Oil on canvas, 6 ft ½ ins × 4 ft 10½ ins (1.84 × 1.49 m).

■ WEDDING FEAST AT CANA

Veronese (Paolo Caliari, 1528-1588) began the *Wedding Feast at Cana* for the refectory of the Benedictine monastery on the Venetian island of San Giorgio Maggiore in 1562. It depicts an episode taken from the Gospel of Saint John, Christ's first miracle, the changing of water to wine at a wedding celebration he attended with his mother. Veronese transforms the little Galilee town of Cana into a stupendous Venetian palace embellished with classical statues, colonnades and a grand terrace overlooking the open-air banquet. The placement of Christ, the Virgin Mary, and the apostles at the center of the composition, with Jesus' head at the exact center of the painting's diagonals, firmly establishes the religious nature of the scene. Still, although Veronese respects the monks' commission, he also transposes the banquet into a sumptuous sixteenth-century Venetian feast, going so far as to fill the foreground with likenesses of his contemporaries Titian, Tintoretto, Jacopo Bassano, and Andrea Palladio, as well as himself in the group of musicians. The celebration is refined and worldly. Veronese's genius—his talent for color in sweeping compositions populated with richly costumed figures bathed in an atmosphere of serene elegance—is evident from his earliest work. Starting in 1553, he executed large decorative cycles in Venice which confirmed his talent in this area, as well as his spatial mastery in sweeping perspectives, surprising foreshortening, and clear, luminous color. After completing the ceil-

ing and walls of the Church of San Sebas-
tiano, Veronese undertook an immense
series of paintings for the Villa Barbaro in
Maser, a masterpiece of Venetian painting
featuring trompe l'oeil decoration. Upon
finishing the *Wedding Feast at Cana*,
Veronese commenced work on the ceil-
ings of the Doge's Palace in Venice. In his
Rape of Europa, the artist adopts a more
intimate scale, lending special, tender

attention to the figures and landscape. The
inexhaustible richness of Veronese's uni-
verse, linked to Venetian pomp and plea-
sures, was a source of unending inspiration
to later masters of painting such as Rubens
and Tiepolo.

Veronese, *Wedding Feast at Cana,* 1563.
Oil on canvas, 21 ft 16¼ ins × 32 ft 5¾ ins
(6.66 × 9.90 m).

■ WINGED BULLS OF KHORSABAD

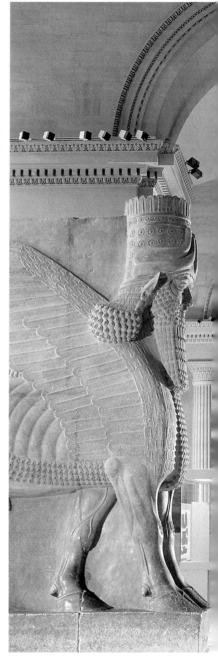

Two hundred courtyards and rooms, a mile and a quarter of sculpted decoration, a residence spanning ten hectares: such was the palace of Sargon II (721-705 B.C) built at the heart of the monarch's new capital which was founded in 713 B.C. on the site of modern-day Khorsabad, in Iraq.

The palace was inaugurated in 706 B.C., but the town was abandoned the following year after Sargon died in a military campaign. The city and palace gates were flanked by two immense stone colossuses over 13½ feet (4 meters) tall: two bearded and winged monsters with crowned human faces and the bodies of bulls. Because of their five hooves, when viewed from an angle these creatures seem to move forward; when approached from the front they appear solidly still.

Massive stone figures were first introduced in Mesopotamia to magnify and glorify the monarch. Between the ninth and seventh centuries B.C., the Assyrians practised an aggressive policy of violent conquest and repression; their sculpted walls bore witness to their overwhelming might. Under the reign of Assur-bani-pal (668–627 B.C.) the Assyrian Empire extended as far as Egypt, but it was defeated in 612 B.C. by a coalition of Medes and Babylonians.

In 1843 and 1844, at a time when the only evidence of these civilizations was to be found in Biblical accounts, Paul-Émile Botta, the French consul to Mossul, discovered the remains of the palace of Sargon II, king of Assyria, during evacuations in search of the city of Nineveh, a splendid Babylonian city immortalized in the Bible. Botta sent for the draftsman Eugène Flandin to document all sculptural and decorative elements, and dispatched the stone colossuses to France by boat. Today they are installed in the Khorsabad courtyard, a setting evocative of the imposing grandeur of Assyrian palaces. The works, shipped to the Louvre by Botta, made the opening of the "Assyrian Museum" in 1857

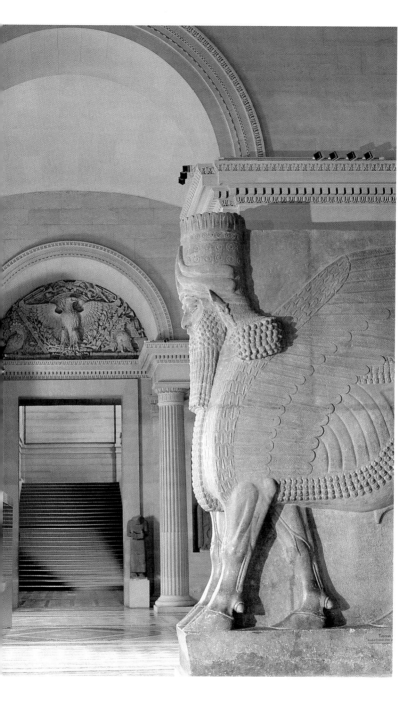

possible, revealing Assyrian civilization to the public and leading to the founding of a new academic discipline, Assyriology. The Louvre remains associated with French excavations in the East today.

View from the Khorsabad courtyard.
Winged Bulls of Khorsabad, Assyria, Palace of Sargon II, late eighth century B.C. Gypsum, 13 ft 9 ins × 14 ft 4 ins (4.20 × 4.36 m).

Winged Victory of Samothrace, early second century B.C. Marble and plaster, 10 ft 9 ins (3.28 m).

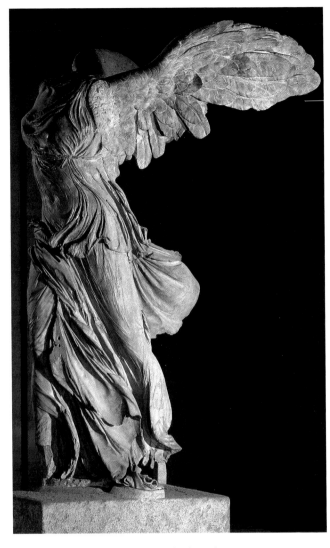

■ Winged Victory of Samothrace

In 1883, twenty years after its discovery on the island of Samothrace, the *Victory* was placed at the top of the Daru* staircase, where it appears as if posed on the prow of a ship to proclaim the victory of the people of Rhodes. From the archaic era on, the Greeks symbolized victory with a winged female figure called Nike. This statue was made at the beginning of the second century B.C. to commemorate a naval victory of Rhodes. The majesty messenger is carried by the winds, her tunic plastered to her form and her wings deployed behind. The monument was erected by the Greeks at the top of a hill overlooking the sanctuary of the Cabiri, where the headless and armless statue was found. The right wing was reconstructed in plaster. Victory's expansiveness and the sculptor's handling of drapery are reminiscent of the Pergamum altar built between 180 and 169 B.C.

C H R O N O L O G Y

1187 First known reference to the site of the Louvre.

1190 Philippe Auguste (r. 1180–1223) builds walls around Paris and then constructs a donjon and fortress.

1364–69 Charles V (r. 1364–80) directs his architect Raymond du Temple to transform the fortress into a more comfortable living space.

1528 François I (r. 1515–47) tears down the donjon and clears the Cour Carrée. He receives the Emperor Charles V at the Louvre in 1540.

1546 The architect Pierre Lescot begins reconstruction work on the Louvre. Under Henri II (r. 1547–59) the new wing in the Renaissance style, a pavilion and another wing are added.

1550 The sculptor Jean Goujon creates the Caryatids for the ground floor hall.

1564 Catherine de' Medici commissions Philibert Delorme to build the Tuileries Palace.

1566 Charles IX (r. 1560–74) has the Petite Galerie built, including a passage linking it to the Tuileries.

1594 Henri IV (r. 1589–1610) enters Paris. Work on the Grande Galerie connecting the Louvre and the Tuileries Palace begins.

1639 Louis XIII (r. 1610–43) decides to continue work interrupted after Henri IV's assassination. Jacques Lemercier builds the Pavilion de l'Horloge, part of his endeavor to quadruple the size of the medieval court.

1652 Anne of Austria and her son Louis XIV (r. 1643–1715) move into the Louvre.

1660 Louis Le Vau draws up plans for expanding the Louvre. The southern wing goes up between 1661 and 1663; the Louvre's size is quadrupled. Between 1662 and 1664, the Galerie d'Apollon is decorated under the direction of Charles Le Brun.

1662 A carrousel is placed in the Tuileries courtyard in honor of the birth of the heir to the throne.

1665 Bernini's project for the eastern façade and central pavilion begins—and is quickly interrupted. In 1668 Claude Perrault, Louis Le Vau, François d'Orbay and Charles Le Brun renew the project. Ten years later the Colonnade is complete. The southern Seine-side wing is expanded to harmonize with its proportions.

1672 The Académie Française is installed in the Louvre.

1692 The Royal Academy of Painting and Sculpture is established permanently in the Louvre. The first exhibition takes place in 1699.

1768 The Marquis de Marigny proposes the first Louvre Museum.

1789 Louis XVI (r. 1774–92) leaves Versailles to occupy the Tuileries Palace.

1793 The Muséum des Arts opens in the Grande Galerie. Hubert Robert proposes new display methods.

1798 Works seized during Napoleon's campaigns enter the Louvre. The inauguration of Anne of Austria's apartments as the antiquity museum takes place in 1800.

1802 Dominique Vivant, Baron Denon, is named Director of the Museum which becomes the Napoleon Museum in 1803.

1806 The Carrousel's triumphal arch is built in celebration of Napoleon I's army. Napoleon moves in to the Tuileries Palace.

1811–14 The North Staircase and the Midi Staircase are decorated in anticipation of the Emperor Napoleon's move to the Louvre.

1815 Works plundered by the Revolutionary and

Napoleonic armies returned to Prussia. Veronese's *Wedding Feast at Cana* remains at the Louvre in exchange for a painting by Le Brun.

1826 Charles X (r. 1824–30) names Jean-François Champollion Director of Egyptian Antiquities. The Charles X Museum is inaugurated.

1847 The first Assyrian antiquities arrive at the Louvre.

1849 The project of linking the Louvre and the Tuileries is revived under the Second Republic.

1851 The architect Félix Duban completes the decoration of the Galerie d'Apollon and heads up the decoration of the Salon Carrée and the Salle des Sept Cheminées.

1852 The Emperor Napoleon III (r. 1852–70) commissions the architect Ludovico Visconti to connect the Louvre and the Tuileries Palace.

1854–57 Hector Lefuel takes over after Visconti's death and, with

the construction of the wings of the Cour Napoléon, completes the Nouveau Louvre.

1861 The Minister of State's apartments are inaugurated. The decoration of the Salle du Manège is finished.

1862 The Napoleon III Museum opens. The Campana Collection, purchased a year earlier, is exhibited.

1871 After the bloody week of the Commune, a small group of Communards sets fire to the Tuileries Palace. The remains are leveled in 1883. The Third Republic (1870–1940) assigns the Richelieu wing to the Ministry of Finance.

1914 Artworks are evacuated to Toulouse during the First World War.

1926–38 Henri Verne, Director of France's Musées Nationau x, conceives a new plan for the Louvre. Work is undertaken between 1930 and 1938 and then resumes after the Second World War.

1938–39 On the eve of the Second World War, artworks are evacuated to Chambord and then divided between isolated repositories in chateaux and abbeys in the countryside around the Loire Valley.

1953 Work on the Louvre continues under the Fourth Republic. Georges Braque painted his *Birds* on the ceiling of the Salle Henri II.

1968 The Flore Pavilion opens to the public.

1981 President Mitterrand launches the Grand Louvre project. The wing occupied by the Ministry of Finance is restored to the museum. Ieoh Ming Pei is chosen to design the structures to provide for the museum's expansion and increased public attendance.

1984–86 Digs in the Cour Carrée and the Cour Napoléon uncover the Louvre's medieval past and Le Vau's wall.

1989 On the bicentennial of the French Revolution the glass pyramid is

inaugurated. It becomes the main entrance to the Louvre. The Ministry of Finance leaves the Richelieu wing.

1990 New excavations reveal the moat of Charles V's castle. Restoration of all the Louvre's façades begins.

1992–98 The museum is reorganized. In 1992 the French Painting halls in the Cour Carrée open. In 1993 the Richelieu wing becomes accessible to the public. The Denon wing's European Sculpture halls are inaugurated a year later. In 1997–98 the Department of Egyptian Antiquities is completely renovated. The Sackler wing opens in 1997, exhibiting oriental antiquities of the first millennium. 1998 marks the new hanging of Italian Painting in the Salon Carrée of the Grande Galerie.

2000 The Sessions Pavilion opens to the public, showing masterpieces from Africa, Asia, Oceania and the Americas.

I N D E X

Musée du Louvre

75058 Paris cedex 01
Main entrance: through the Pyramid.
Other Entrances:
 - Galerie du Carrousel (through the Jardin du Carrousel,
 or 99 rue de Rivoli).
 - Porte des Lions (Entrance for Arts of Africa, Asia, Oceania and the Americas, quai des
 Tuileries, 9:00 AM to 5:30 PM. Wednesday until 9:45 PM. Closed Friday).
 - Passage Richelieu (For those who already have tickets or special entry passes, 9:00 AM
 to 6:00 PM).

Contact

Telephone: 01 40 20 51 51
Web: www.louvre.fr
Visually impaired or reduced-mobility: 01 40 20 59 90

Hours

Open every day except Tuesdays and January 1, April 15, May 1, May 8, June 3, November
 11, December 25.
Permanent Collections: 9:00 AM to 6:00 PM.
Monday Evening: Access to some galleries continues until 9:45 PM.
Wednesday Evening: All galleries open until 9:45 PM, except the Campana Collection (Sully
 Pavilion, 2nd floor) which closes at 5:30 PM.
Last Tickets: 5:15 PM (9:15 PM Monday and Wednesday).
Galleries Close: 5:30 PM (9:30 PM Monday and Wednesday).
Napoleon Hall: 9:00 AM to 10:00 PM.
Temporary Exhibits and the Louvre's medieval foundations: 9:00 AM to 6:00 PM,
 Wednesday until 9:45 PM. Closed Tuesday.
Historical Galleries: 9:00 AM to 9:45 PM, Friday until 6:00 PM.

How to get there

Metro stations: Palais-Royal/Musée du Louvre, Louvre-Rivoli, or Tuileries.
Buses: 21, 27, 39, 48, 68, 69, 72, 81, 95.
Parking for cars and tour buses open 7 days, 7:00 AM to 11:00 PM.

Admission

Before 3:00 PM: 46 F. After 3:00 PM and all day Sunday: 30 F.
Free admission for those under 18 years of age.
Free admission for everyone the first Sunday of every month.

 La Société des Amis du Louvre (Society of the Friends of the Louvre):
01 40 20 53 74.

SELECTED BIBLIOGRAPHY

Geneviève Bresc-Bautier, *The Louvre: An Architectural History*, New York, Vendome Press, 1995.

Jean-Pierre Cuzin and Claire Marchandise, *Dictionnaire du Louvre*, Paris, RMN, 1997.

Ernst Hans Gombrich, *The Story of Art*, London, Phaidon Press, 1995.

Alain-Jean Lemaître and Erich Lessing, *Florence and the Renaissance: The Quattrocento*, Paris, Terrail, 1997.

Michel Laclotte, *Treasures of the Louvre*, New York, Abbeville Press, 1997.

Eric Meyers, *Oxford Encyclopedia of Archaeology in the Near East*, Oxford, OUP, 1996.

V. H. Minor, *Baroque and Rococo: Art and Culture*, New York, Harry N. Abrams, 1999.

Peter Rautmann, *Delacroix*, Paris, Citadelles & Mazenod, 1997.

William Smith, *Art and Architecture of Ancient Egypt*, New Haven, Yale University Press, 1999.

Titles of all works are as referenced in the *Dictionary of Art*, ed. Jane Turner, New York, Grove Press, 1996.

Photographic credits: All images are from the Réunion des Musées Nationaux (RMN) except p. 30, Musée du Quai Branly/Hugues Dubois. © Adagp 2001 for Georges Leroux.

Editors: Sandrine Bailly, Nathalie Bec
English-language editor: Sophy Thompson
Translated and adapted from the French by Stacy Doris and Chet Wiener
Typesetting: A propos / Julie Houis
Color separation: Pollina S.A., France
Printed and bound by Pollina S.A., France - n° L93846

www.editions.flammarion.com

04 05 06 07 8 7 6 5

FC0471-04-VI
ISBN: 2-0803-0471-2
N° de nomenclature RMN: GK 194831
Dépôt légal: 06/2004

Printed in France